T0131841

Objects on a Table

OBJECTS ON A TABLE

HARMONIOUS DISARRAY
IN ART AND LITERATURE

GUY DAVENPORT

COUNTERPOINT
WASHINGTON, D.C.

Library of Congress Cataloging-in-Publication Data
Davenport, Guy.
Objects on a table : harmonious disarray
in art and literature / Guy Davenport.
Includes bibliographical references.
1. Still-life in art. 2. Art. I. Title.
N8251.S3D38 1998
704.9'435—dc21 98-35507

ISBN 1-887178-85-6 (hc.); 1-58243-035-7 (pbk.)

Text and jacket design by Carole McCurdy

Printed in the United States of America on acid-free paper
that meets the American National Standards Institute
Z39-48 Standard.

COUNTERPOINT
P.O. Box 65793
Washington, D.C. 20035-5793

Counterpoint is a member of the Perseus Books Group.

2 4 6 8 9 7 5 3 1
FIRST PRINTING

For Bonnie Jean

CONTENTS

A Remark Beforehand

These essays were originally read at the University of Toronto as the Alexander Lectures for 1982. However unprofessional and even deplorable they will appear to some scholars, they may be of interest to the common reader and intelligent children. Each is itself a disarray of perceptions and conjunctions in which the unlikelihood of harmony vies with the promise of coherence in the titles.

My instigation to look hard at still life came from Carl Nordenfalk's "Van Gogh and Literature," particularly his analysis of *Still Life with Onions,* which I have taken as a model.

I

A BASKET OF SUMMER FRUIT

B etween the gathering of food and its consumption there is an interval when it is on display. To this arrangement of eggs on the sideboard, as may be, brought in from the henhouse (in Tuscany in the time of Horace, in the South Carolina of my childhood, in Yorkshire, in Normandy), apples and pears from the orchard, a string of fish from the river, a brace of partridges flecked with blood, a basket of squash and beans from the garden, the Dutch gave the name *still life* around the middle of the seventeenth century. A. P. A. Vorenkamp tells us in his history of Dutch still life that the word comes from the jargon of painters: *leven,* "alive," for drawings made from a

model. A *vrouwenleven* was a female model, and one who, from time to time, while posing, needed to move; a *stillleven*—fruit, flowers, or fish—remained still. This was a general term, used by painters and dealers. People who fancied still life for their walls, of whom there were more in Renaissance Netherlands than at any other time in history, used such designations as *ontbijt*, breakfast or snack; *banket*, by which the Dutch mean not only our banquet but a copious array of pastries; or the sumptuous *pronkstillleven*, an ostentatious table such as Chaucer gives the Franklin, who was "Epicurus owene sone":

> His breed, his-ale, was alweys after oon;
> A bettre envyned man was nowher noon.
> Withoute bake mete was nevere his hous,
> Of fissh and flessh, and that so plentevous,
> It snewed in his hous of mete and drynke,
> Of alle deyntees that men koude thynke.
> After the sondry sesons of the yeer,
> So chaunged he his mete and his soper.
> Ful many a fat partrich hadde he in muwe,
> And many a breem and many a luce in stewe.
> Wo was his cook but if his sauce were
> Poynaunt and sharp, and redy al his geere.
> His table dormant in his halle alway
> Stood redy covered al the longe day.

The *pronkstillleven,* as we shall see, can be used to voluptuous ends, as by Keats in "The Eve of St. Agnes," or to joyous ones, as with Dickens's Christmas feasts, or comic ones, as with the grand spreads laid out by Thomas Love Peacock's epicurean squires and eccentrics, or to elaborately symbolic ends, as with Joyce in "The Dead" or Edgar Allan Poe—with another kind of *pronkstillleven,* of philosophical and poetic emblems such as we find in Holbein's *Ambassadors* and Dürer's *Melencolia.* Epicurean, let us note, has its own history as a kind of table fare. Historically it should mean the simple meal of a philosopher of admirable restraint: an actual meal of Epicurus comes down to us—goat cheese, plain bread, and a pitcher of cold spring water—equaled, perhaps, by Milton's heroic late-night refreshment of a pipe of tobacco and a glass of cold water. But "Epicurean" turned into the sense the Arabic word from which his name derives still has, *bikouros* (especially used by Moroccans of the Anglican clergy), high living and rich eating.

Still life begins in history at two points, in Egypt and in Israel, establishing two themes that will persist in unbroken tradition until our time.

Primitive peoples feed their dead. In the most ancient of graves we find dishes and cruses. From the earliest times that we know of in Egypt, food was given by pious offspring to their deceased parents: the *ka,* or soul, could eat. Its hieroglyph is that prehistoric and lasting gesture of praise, uplifted arms. And when, after a long time, there was no more family to feed actual food to an ancestor, there was a picture of a meal painted on the tomb wall, and the *ka* could survive on that until the

coming forth by day of Osiris, when time will stop, and the righteous dwell forever in the eternal July of the redeemed Egypt.

That, it seems to me, is the real root of still life—an utterly primitive and archaic feeling that a picture of food has some sustenance. Something close to this idea must have been behind the neolithic cave paintings, which almost invariably depict animals. All the theories make sense: that these animal images were drawn in the earth's womb to enhance fertility; that the image was identified magically with the animal, and that to slay the image would ensure slaying the animal; or a more engaging theory, that the images were restorations of slain animals, an offering to some god of a replacement of a part of his creation that we, to stay alive, have had to kill and eat.

Whatever the truth of picturing food, the reasoning will have transmuted, culture by culture, over the millennia. Franz Kafka tells us this parable:

> Leopards break into the temple and drink to the dregs what
> was in the sacrificial pitchers; this is repeated over and over
> again; finally it can be calculated in advance, and becomes a
> part of the ceremony.

In the study of still life, we must be prepared for leopards that have become a part of the ceremony. Still life persists for four thousand years, and deserves study for that alone. The portrait arises and falls away, or is forbidden, or loses significance (as in our times). Landscape is inter-

mittent—we rarely find it even in descriptions. Pausanias described Greece without a single view of meadow or wood, riverbank or mountain. All the genres of painting except still life are discontinuous, and only the lyric poem, or song, can claim so ancient a part of our culture among the expressive arts.

The other beginning of still life, as a subject, is in the Book of Amos. A prophet of the eighth century B.C., Amos was a contemporary of Jeroboam the Second (783–741), after whose reign the kingdom of Israel fell into confusion and collapse. Amos, a dresser of sycamore trees and a shepherd, was given a vision by God. At Amos 8:1–2,

> Thus hath the lord GOD shewed unto me, and beholde, a basket of summer fruit. And he said, Amos, what seest thou? And I sayde: a basket of summer fruit. Then said the LORD unto me, The ende is come upon my people of Israel; I will not again pass by them any more.

The King James translators put as their rubric in the margin: "By a basket of summer fruit, it is shewed the propinquitie of Israel's end."

Vanitas vanitatem and *memento mori*: a still life becomes a symbol of what we shall have taken from us, though at the moment it is a sign of God's goodness and the bounty of nature.

"Hear this," said Amos, "O ye that swallow up the needy, even to make the poor of the land to fail, saying, When will the new Moone be gone, that we may sell corne? and the Sabbath, that we may set forth

wheat, making the ephah small, and the shekel great, and falsifying the balances by deceit? that we may buy the poor for silver, and the needy for a pair of shoes . . . ?"

To the vision of the basket of summer fruit the Lord adds one of Himself upon a wall made by a plumb line, with a plumb line in His hand.

> And the LORD said unto me, Amos, what seest thou? And I sayd, a plumbline. Then sayd the Lord, Behold, I will set a plumbline in the midst of my people Israel, I will not again pass by them any more. And the high places of Isaac shall be desolate, and the Sanctuaries of Israel shall be laid waste: and I will rise against the house of Jeroboam with the sword.

Plumb line, *anakk;* grief, *anaqah.* Summer fruit, *qayits,* an ending, *qaits.* We shall see that the still life likes puns and double meanings, as in Amos's rhetoric.

If greed, rapacity, and selfishness are the opposite of the grace of a basket of summer fruit, Amos gives us one of the most beautiful of hyperboles at the end of his book, where he describes what might be, if two walk together and be agreed, and man and God walk together.

> Behold, the daies come, saith the LORD, that the plowman shall overtake the reaper and the treader of grapes him that soweth seede, and the mountains shall drop sweet wine, and

all the hills shall melt. And I will bring againe the captivitie of my people of Israel; and they shall build the waste cities and inhabit them; and they shall plant vineyards, and drink the wine thereof; they shall also make gardens, and eat the fruit of them. And I will plant them upon their land, and they shall no more be pulled up out of their land, which I have given them, saith the LORD thy God.

That is, the basket will again be full of summer fruit. We can see that basket—filled with apples, pears, and figs—in Roman mosaics when the empire was at its most orderly and majestic; we can see it in the great renaissance of still life in the Netherlands after the expulsion of the Spanish and while the Dutch were refining the art of living to a high degree. We can see it in nineteenth-century American painting as a celebration of the land's goodness.

Still life is a minor art, and one with a residue of didacticism that will never bleach out; a homely art. From the artist's point of view, it has always served as a contemplative form useful for working out ideas, color schemes, opinions. It has the same relation to larger, more ambitious paintings as the sonnet to the long poem. Petrarch, Wyatt, Shakespeare, Milton, Donne, Hopkins—the sonnet is their study book and their confessional, their meditative form. It is easy to see that still life has been a kind of recreation, a jeu d'esprit, for painters. Manet painting a bunch of asparagus is a man on holiday, like Rossini and Mozart having fun writing comic songs, or Picasso doodling on a tablecloth.

We must not, however, imagine that still life is inconsequential or trivial. Composers work out ideas in string quartets—Beethoven's and Bartók's experimental forms for discovering what can be done with harmonies and tempi—that have become masterpieces. There are artists like Chardin and Braque for whom still life was their major form of expression, as there are poets who have excelled only in the sonnet and the short lyric.

That the kinship of still life with still life down through history is greater than that of landscape with landscape, or portrait with portrait, lies at the center of its mystery. A Roman landscape in mosaic on the wall of a villa, with its archaic placement of trees and figures, its total lack of perspective, is a vision radically different from a medieval landscape with its toy charm and fidgety business (the woodcutter paying no attention to David carrying off Goliath's head; a fisherman in his boat in the river equally indifferent), or a Poussin, or a description by Proust of the meadows around Balbec. But a Roman mosaic of a basket of apples and pears, as in the Vatican's tessellated floor, is wonderfully like baskets of apples and pears of all ages. There is the same nakedness of presentation, the same mute hope of and confidence in the clarity of the subject, a tacitness so deep that we may never get to the bottom of it.

Reiteration is a privilege of still life denied many other modes. Turner's landscapes and interiors begin and end with Turner, not because genius does not repeat but because Turner's time, its spirit and perspectives in history, cannot repeat itself. Turner's wave of time was strong, percussive, and grand, but it was short. Still life belongs in the slow

sinews of a great swell that began with the cultivation of wheat and the fermentation of wine, bread and wine being two of its permanent images. It is an art that is symbiotic with civilization. We must suppose that man in his most primitive state ate like a beast, selfishly and when he could.

Claude Lévi-Strauss in his tetralogy *Les Mythologies* argues that in preparing food for communal consumption, by cooking, by symbolic understanding of the ritualness of eating, and by the evolution of table manners, we crossed over from the wild to the tame, from nature to culture. Certainly the placing of food on an altar to do honor to a god, which is one of the instigations of all still life, is an obvious passage from savagery to civilization, which the Bible locates at the beginning of time already differentiated into the hunter's and the farmer's sacrifice.

In Christ's ministry the table figures as a versatile symbol throughout the Gospels, from the wedding feast of the first miracle to the Last Supper, the bread and wine of which became fixed in European still life, along with other Christian symbols, such as the apple and the pear, which would not go away in the most gaudy Dutch still lifes, or in cubist still lifes, where, on the contrary, they asserted themselves with new vigor.

"Still life" first comes into English in Dryden and Graham's translation (1695) of Dufresnoys's *De Arte Graphica,* or *The Art of Painting*: "His peculiar happiness is expressing all sorts of Animals, Fruit, Flowers and the Still-Life." By 1701 the meaning seems to have narrowed in English to mean trompe l'oeil, and in 1762 we find Horace

Walpole looking down his nose and writing, "He painted still-life, oranges and lemons, plate, damask curtains, cloths of gold, and that medley of familiar objects that strike the ignorant vulgar," from which we gather that the knowing had become bored with the Dutch *pronk-stillleven*. In the third century B.C., by the way, there is a mime of Herondas in which he satirizes pretentious women for admiring the life-likeness of paintings without understanding a great deal of what they were about:

> That naked boy there, look, I could pinch him
> And leave a welt. His warm flesh is so bright
> that it shimmers like sunlight on water.
> And his silver fire tongs; wouldn't Myllos
> send his eyes out in stalks in wonderment,
> or Lamprion's son Pataikiskos try
> to steal them! For they are indeed that real!
> The ox, the herd, and the girl who's with them,
> the hook-nosed man with his hair sticking up,
> they are as real as in everyday life.
> If I weren't a lady, I might scream
> at the sight of that convincing big ox
> watching us out of the side of his big eye.

Here is a sixth-century B.C. Greek table, described in an elegy by Xenophanes of Colophon:

The floor is clean, and all our hands, and the cups.
A slave puts garlands of flowers on our heads,
another passes around myrrh in a flat dish, for perfume.
The mixing bowl and a jar of wine as sweet as honey
and smelling of flowers sits in our midst.
The room is scented with frankincense, and the springwater
for the wine is cold, fresh and pure.
Loaves of bread seem golden, and there is honey and cheese.
There is a bouquet of flowers on the altar in the center.

Xenophanes goes on to say that the meal begins with songs, prayers, and a libation. The prayer is that we might be just to all men. Conversation at a meal, he says, should be light and decent, with no long accounts of books you have read.

We have kept that sense of clean hands and tableware, we have kept the flowers in the middle of the table, and we have kept the sense of a meal as a social gathering with conversation. Still life has concomitantly guided the table as a civilizing occasion.

Greek poetry is rich in still lifes, as was their painting, as we know from the anecdote of the bird that tried to eat Apelles' cherries. Here is a poem to dedicate objects placed on an altar:

His green garden's twytined digging fork,
the curved sickle that pruned and weeded,
the comfortable old coat he wore in the rain,

and his raw oxhide waterproof boots,
the stick with which he set the cabbage sprouts
in long straight rows in rich black loam,
the hoe that chopped the runnels that kept
the garden green all the dry summer long,
for you, Gardener Priapos, the gardener Potamon,
whom you favored, places on your altar.

Another:

To Priapos, god of gardens and friend to travelers,
Damon the farmer laid on this altar,
with a prayer that his trees and body be hale
of limb for yet awhile, a pomegranate glossy bright,
a skippet of figs dried in the sun,
a cluster of grapes, half red, half green,
a mellow quince, a walnut splitting from its husk,
a cucumber wrapped in flowers and leaves,
and a jar of olives golden ripe.

Claude Monet's *The Luncheon* of 1868 (in the Städelsche Kunst-
institut, Frankfurt am Main) shows a sunny room in Argenteuil, of
which we can see some ten feet of floor space, a wall with window in
foreshortened perspective on the left, a far wall with linen closet (and a
maid getting something from it) and a table on which there are two

books with the look of novels, an oil lamp, and a top hat. A round dinner table fills the center of the painting, and two people are seated on its far side: Monet's first wife Camille and his infant son Jean in bib and tucker, wielding a spoon as if he means to ring chimes on his plate. His doll lies discarded under a chair on the lower left of the canvas, and his round hat hangs on the corner of the chair back. On the table, reading from left to right, we see a baguette of bread, a large bowl of green salad, cruets of oil and vinegar, a plate of white grapes, a bowl of jelly, a platter of crudités, a bottle of red wine, and a carafe of water. On Camille's plate is an egg in an egg cup, and there is a second egg on her plate. Monet's plate is charged the same, except for a heel of the loaf added, and a folded copy of *Le Figaro*. He has not arrived, and his cane-bottomed chair is pulled back.

Let us study the design. If we make two axes, at right angles, one from us to the back wall, and one across the table, we find that we have connected egg with egg, the heel of bread with a glass of wine. Other lines passing through the same point connect son's hat with top hat, newspaper with novels, oil cruet with oil lamp, loaf of bread with bottle of wine, and so on, until we see that the still life on the table is arranged so that the radii of a superimposed circle connect objects that are kin to each other in the traditional manner of still-life composition. We detect a system of derivatives. The wine derives from the grapes, son from mother. A sewing basket on the extra chair is a source for little Jean's clothes. We are even shown more tablecloths in the linen closet. Before we make so obvious an observation as that the food so beauti-

fully displayed is the nourishment of their life, let us notice that Monet is always sharply aware of sources and derivations: that is his great underlying theme. The floormat is straw; the chairs are bamboo with plaited cane seats, the sewing basket is wicker; the bread is from that accomplished grass, wheat, to which the Mediterranean people all attributed man's transition from hunter to farmer, and thence to cities and civilization. The painting at its most abstract thus changes from being a charming tonal study of domestic life to one in which the artist has traced lines to this focus. The Parisian newspaper and novels announce lines of transport to this country farmhouse; the top hat and rubber ball, Madame's locket and the silverware indicate craftsmen and shops that supply this household.

Once Monet had reached maturity, he displayed a fascination with roads and paths, like Pissarro and Cézanne, and indeed all the great Impressionists. Highways, whether rail or carriage or footpath, are the one subject that the Impressionists were never very far from. Was it because roads for the first time in European history all became safe and used by everybody? Was it a new awareness of mobility? Monet's *Gare St-Lazare* takes on a new light when we notice all these roads, even if we know that it is the station where one takes the train from Paris to Giverny. And in his full maturity, and on into old age, Monet devoted himself to two subjects—his lily pond, a diversion of the river Epte across the road from his house at Giverny, and the haystacks in the field adjacent. Add to this the Epte itself, with its lines of poplars, and you have all of late Monet in an acre of French countryside, so dull and

ordinary that no photographer would waste a frame of film on it, and so bland that today one passes it in an automobile with no awareness that here is the original of some of the most beautiful landscapes in all of art.

Europe, Braudel tells us, was all marshlands and forest when men began to clear it for agriculture. Hundreds of years went into draining marshes to make land on which wheat would grow. Two of Monet's most persistent subjects thus leap into relief—the lily pond, which is a marsh, and the haystacks. And the river Epte is a drainage system into the Seine and on into the sea. All of Monet's painting thus becomes a study of the interaction of man and the earth, and of all the processes of light and water. His other concerns are complementary: the beauty of women and children, the beauty of flowers, and the mutations of weather. Only Thoreau was as assiduous an inspector of snowstorms and meadows.

The very first daguerreotype is a still life. For it, Louis-Jacques-Mandé Daguerre assembled, in 1837, an assortment of plaster casts and other objects on a tabletop. Daguerre had begun experiments in photography with its inventor, Joseph-Nicéphore Niepce, who, in 1826, eleven years before, had made a photograph of a courtyard that needed all of a day's sunlight for its exposure. Its dreary starkness and illogical shadows are not so much a picture of space as one of time—shadows and naked light on walls that would return in the still lifes of Giorgio De Chirico and the plays of Samuel Beckett.

Daguerre was a painter, stage designer, and operator of the Diorama,

a grandiose display of large paintings under dramatic lighting that attempted to fuse illusion and perception—in a way that would lead to our moving pictures on large screens.

In this first photographic still life we have, from left to right (forgetting the lateral reversal of daguerreotype), an empty bowl, a plaster bas-relief of Da Vinci's head of a warrior copied from the silverpoint in the British Museum, a wicker flask hanging by a string from the wall, a framed print of two clothed figures embracing in greeting or farewell, a plaster ram's head, two plaster winged heads of angels, a shallow round box, and a paper knife. Beside the table and leaning against it is a plaster bouquet of flowers and leaves.

The textures are rich, the play of light and shadow Rembrandtesque. An analysis of its iconography will show that all the objects are traditional props, as if photography had nothing new to bring to the art of still life. To see where still life was flourishing at this time, we must turn to prose description in narrative.

In July 1845, Hugh Miller, the forty-three-year-old Scottish geologist and editor of the Free Kirk newspaper *The Witness,* took his annual holiday, as always a geological expedition, on the yacht *Betsey,* which was a floating outlaw church. Its captain, the Rev. Mr. Swanson, and his first mate John Stewart, together with Stewart's companion, "a powerful-looking, handsome young man, with broad bare breast," were the full complement of the crew. With the immemorial stalwartness of Scottish pluck, whether in dodging the British customs patrol or preaching the Gospel, the *Betsey* sailed from congregation to congregation in the

Hebrides to offer sermons in English or Gaelic, or if necessary in both.

Miller, one of the most popular Victorian writers, was also one of the finest prose stylists in English. His *Old Red Sandstone* inspired Longfellow's "Hymn of Life," and a phrase from his *Testimony of the Rocks*—"a day of dappled seaborne clouds"—drifts through the mind of Stephen Dedalus in *A Portrait of the Artist as a Young Man* just before his encounter with a girl wading in the shallows. The phrase encodes a fall of Icarus, or Lucifer, if we know Miller's text, where he is thinking of Milton's fall of Mulciber

> thrown by angry Jove
> Sheer o'er the crystal battlements: from morn
> To noon he fell, from noon to dewy eve,
> A summer's day; and with the setting sun
> Dropt from the zenith like a falling star.

Early in his account of this voyage of the *Betsey*, Hugh Miller describes the cabin:

> A well-thumbed chart of the Western Islands lay across an equally well-thumbed volume of Henry's "Commentary." There was a Polyglot and a spy-glass in one corner, and a copy of Calvin's "Institutes" with the latest edition of "The Coaster's Sailing Directions" in another; while in an adjoining stateroom, nearly large enough to accommodate an arm-

chair, if the chair could have but contrived to get into it, I caught a glimpse of my friend's printing press and his case of types, canopied overhead by the blue ancient of the vessel, bearing, in stately six-inch letters of white bunting, the legend "FREE CHURCH YACHT." A door opened, which communicated with the forecastle, and John Stewart, stooping very much, to accommodate himself to the low-roofed passage, thrust in a plate of fresh herrings, splendidly toasted, to give substantiality and relish to our tea. The little rude forecastle, a considerably smaller apartment than the cabin, was all aglow with the bright fire in the coppers, itself invisible; we could see the chain-cable dangling from the hatchway to the floor, and John Stewart's companion . . . in his shirt sleeves, squatted full in from of the blaze, like the household goblin described by Milton, or the "Christmas Present" of Dickens.

To this rich still life there is later added "a fragment of rock . . . charged with Liassic fossils," brought to the yacht by a Mr. Elder with a note saying that "the deposit to which it belonged occurred in the trap immediately above the village mill; and further, to call my attention to a house near the middle of the village [of Tobermory], built of a mouldering red sandstone, which had been found *in situ* in digging the foundations" [Miller 1858: 26–27].

We think of Joseph Wright of Derby because of the gleam of firelight on copper, and because the charm of Miller's description avoids

any effect of prettiness. As in a Holbein, books, maps, and scientific in-
struments are integral to the subject. Henry's biblical commentary and
Calvin's *Institutes* are clearly meant by Miller to be symbolic in their
arrangement with sea charts and a spyglass: we detect the hand of
Bunyan. Dürer might have placed these symbols just so if he had
wished to link emblems of the soul's pilgrimage to God with those of
wayfarers preaching the Gospel among rocky islands in a treacherous
sea.

The plate of fish completes this picture of Christian endeavor,
though completion is not Miller's end: he chimes and echoes. To the
real fish he adds a fossil, stating the theme and problem of all his
books, his times, and the theme of his life, for the fossil is 190 million
years old and requires us to read the Bible in an understanding other
than literal.

Milton's household goblin, in "L'Allegro":

> To earn his Cream-bowl, duly set,
> When in one night, ere glimpse of morn,
> His shadowy Flail hath thresh'd the Corn
> That ten day-labourers could not end;
> Then lies him down the Lubber Fiend,
> And, stretch'd out all the Chimney's length,
> Basks at the fire his hairy strength;
> And Crop-full out of doors he flings
> Ere the first Cock his Matin rings. [106–114]

Miller's mate's friend on the *Betsey* by the fire in the coppers is also aligned with the Spirit of Christmas Present at Bob Cratchit's, with its humble cheer and frugal repast. Did the chain cable hanging from the hatchway to the floor recall Marley's ghost hung with chains, and thus add an allusion to Dickens? To play Dupin further: Miller exercised considerable ingenuity in harmonizing Genesis and geology, and the anguish it caused him led to his suicide in 1856, after he endured pitiful illusions of being followed and found himself confusing the sequence of mundane events so that he could not remember from one minute to the next what he had done or where he had been.

Miller's vision of geology followed that of Agassiz and others: creation had happened over and over for millions of years, each creation destroyed in time by a worldwide catastrophe that Miller saw in the fossil record. The strange Silurian creatures of the Old Red Sandstone had all died in fear, fleeing the obliteration of the Calvinist god who had made such monsters, a world of tropical forests of ferns, and a perpetual fog of steam, and then negated all this blind fertility with total devastation, only to begin again with new monsters, all but brainless reptiles slithering through swamps of slime, until in this, the creation we inhabit, the rational creature man was made in the image of his maker.

On the same page as Miller's still life of the *Betsey*'s congenial cabin, he tells of the surviving pieces of the Spanish ship *Florida*, part of the Great Armada that was wrecked by one of God's catastrophes, and with the same dip of ink he remarks on the melancholy look of Tobermory, a

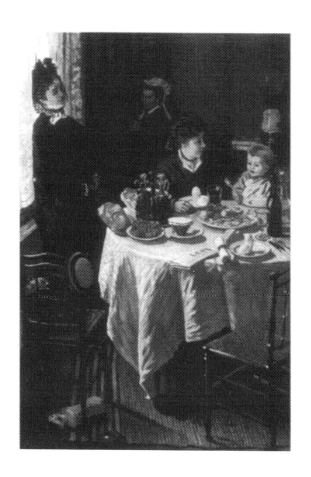

Claude Monet, *The Luncheon (Le Dejeuner)* (detail). 1868.
Städelsches Kunstinstitut, Frankfurt-am-Main, Germany.
Courtesy Bridgeman Art Library, London/New York. ED130127.

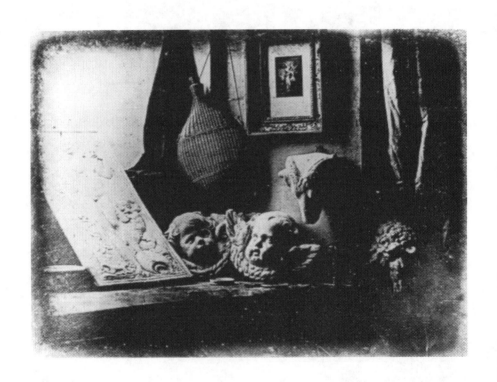

Louis-Jacques-Mandé Daguerre, *Intérieur d'un cabinet de curiosité.*
Daguerreotype, 1837. © Collection de la Société Française de Photographie, Paris.

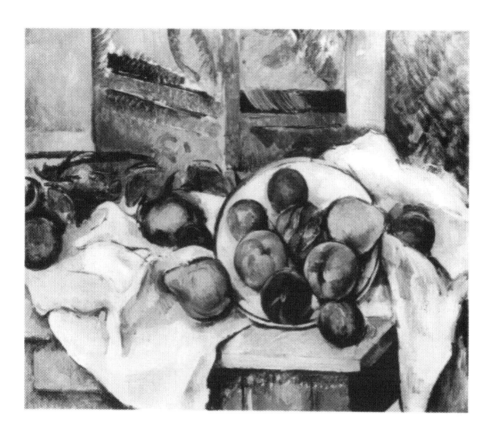

Paul Cézanne, *Table, Napkin, and Fruit (Un coin de table).*
1895–1900. Photograph © Reproduced with the Permission of
The Barnes Foundation™, All Rights Reserved, Inv. no. 711.

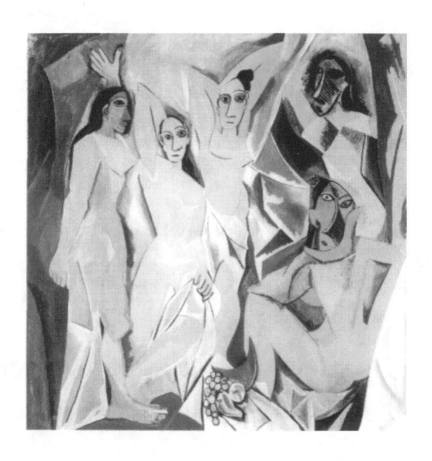

Pablo Picasso, *Les Demoiselles d'Avignon.* Paris (June–July 1907).
Oil on canvas, 8 ft. x 7 ft. 8 in. (243.9 x 233.7 cm.).
© 1998 Estate of Pablo Picasso / Artists Rights Society (ARS), New York.
The Museum of Modern Art, New York. Acquired through the Lillie P. Bliss
Bequest. Photograph © 1998 The Museum of Modern Art, New York.

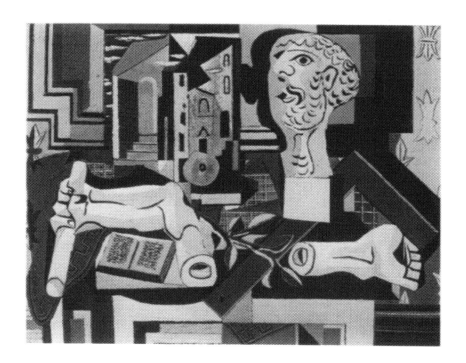

Pablo Picasso, *Studio with Plaster Head*. Juan-les-Pins, summer 1925.
Oil on canvas, 38-5/8 x 51-5/8 in. (97.9 x 131.1 cm.).
© 1998 Estate of Pablo Picasso / Artists Rights Society (ARS), New York.
The Museum of Modern Art, New York. Purchase.
Photograph © 1998 The Museum of Modern Art, New York.

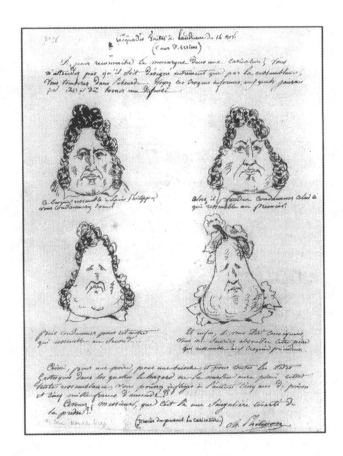

Charles Philipon, *La Métamorphose du roi Louis-Philippe en poire*. 1831.
Reproduced from the Collections of the Library of Congress.

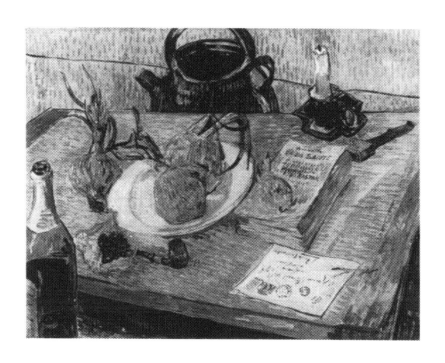

Vincent van Gogh, *Still Life with Onions*, 1889.
Collection Kröller-Muller Museum, Otterlo, The Netherlands, inv. no. 288-13,
cat. no. 223. © Stichting Kröller-Muller Museum. Photograph by Tom Haartsen.

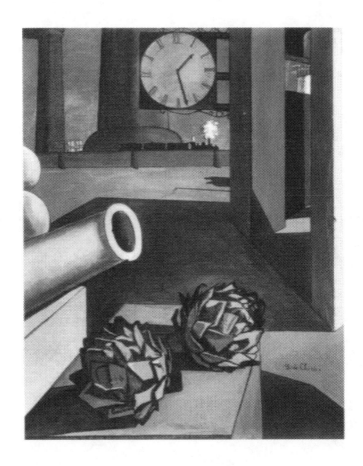

Giorgio De Chirico, *Conquest of the Philosopher*, 1914.
Courtesy of the Art Institute of Chicago. © Estate of Giorgio
De Chirico / Licensed by VAGA, New York, NY.

town that did not grow but was built all at once, "as Frankenstein made his man."

The fossil from the lower Jurassic, driftwood washed up from the Invincible Armada, a suffering Ghost from Dickens: Miller's still life begins to display a transparency through which we can see a Calvinist suspicion of well-being as the mask of disaster to come, if not now, surely in all too short a while—and we may not be prepared. Let us imagine that Matthew Henry's great commentary (which George White-field read through four times, on his knees, in the six folio volumes of 1710, the inspiration of Cowper's hymns, part of the furniture of every Protestant parsonage for 280 years, and still in print) is open to the book of Amos, at chapter eight, verses 1–2, with which this chapter began. "The approach of . . . [Israel's] threatened ruin," Henry wrote, is represented by the basket of summer fruit that Amos saw in vision.

> He saw a basket of summer fruit gathered and ready to be eaten, which signified 1. That they were ripe for destruction, that they lay ready to be eaten up, 2. That the year of God's patience was drawing toward a conclusion; it was autumn with them. 3. Those we call summer fruits will not keep till winter, must be used immediately, and [are] the emblem of this people, that had nothing consistent in them. . . . It signifies that the end has come upon my people Israel. What was said in Chapter eight is here repeated as God's determined resolution, "I will not again pass by them anymore."

Translate that into Gaelic, make a sermon of it for a people, some of whom have never seen a tree, who live out of the ocean and from oats persuaded to grow out of rock, and add to it Miller's study of these rocks and their record of creation after creation, each matured in eons and then destroyed, and the charming array of fish and Calvin's *Institutes* and the polyglot Bible and the instruments of navigation in the *Betsey*'s forecastle figure in the long tradition of still life as the peculiarly equivocal symbolism of tragedy implicit in all beauty.

II

THE HEAD AS FATE

Urban man has a folklore that has flourished with the energy and success of myth and fable, and has appropriated, perhaps through an organic, unconscious design, symbols native to the art of still life. The printed book began as its medium; the moving picture, radio, and television continue the process. By urban folklore I mean Don Quixote, Sherlock Holmes, Tarzan of the Apes: figures whose diffusion from their texts was instantaneous, other authors taking them up, so that their locale as characters is the public imagination, the text being only a source or classical reference point for their reality.

Sherlock Holmes's rooms at 221B Baker Street are known to us all. There is a table with chemical apparatus. There is a violin, a multiple-volumed scrapbook of newspaper clippings about crimes. There is a Persian slipper jackknifed to the mantelpiece in which Holmes keeps his tobacco. This room began as Roderick Usher's, in Poe's tale "The Fall of the House of Usher," and as Auguste Dupin's room in Paris, in Poe's tales of that proto-Holmesian detective. In a deeper sense, this room began as Leigh Hunt's, where Keats wrote "Sleep and Poetry." It is the philosopher's lair, the poet's, the den of the man of feeling and sensitivity. In Mario Praz's study of interiors—a study that descends from Poe's seminal essay on the philosophy of furniture—we can see many such rooms: the studies of Goethe, Alexander von Humboldt, Cuvier, of scientists and poets, dilettantes, collectors, amateurs of all sorts.

In Holmes's room at one time there was a bust of the detective, sculpted by one Oscar Meunier. It is, we recall, a decoy for a deadly silent air rifle. It is a means for Holmes to be in two places at once. But it also completes an inventory of items on a tabletop requisite for a kind of still life.

This paradigmatic still life is of books and the implements of philosophical contemplation: a pipe, a musical instrument—a violin in Holmes's case, a guitar in Roderick Usher's, a flute in Thoreau's (whose tabletop at Walden Pond was a copy of the *Iliad* in Greek, a rock, a leaf, and the flute)—a wineglass and bottle (coffee or teapot with Holmes, wine being for his dinners to celebrate the triumph of a case), and a classical bust.

In these things we recognize the schema of a typical cubist still life by Picasso and Braque, as well as a blueprint for still life as it is accepted in

our time. It is possible to trace this tabletop back to St. Jerome's study, with books and lion, of medieval tradition.

But let us return to Holmes's bust. The Oscar Meunier who made it may well be a real person, like Holmes's ancestor the French painter Horace Vernet. The likelihood, however, is that Conan Doyle invented the name, taking Meunier from a contemporary Belgian sculptor, Constantine Meunier, who did busts, and from his acquaintance and fellow novelist Oscar Wilde, who wrote in *The Picture of Dorian Gray* a book about a work of art that suffered the fate from which its sitter was, for a time, magically excused, just as Holmes's bust died in his stead.

The smashing of busts had happened before in Holmes stories, and a figure at a window meant to deceive had been used in "The Case of the Copper Beeches." In "The Adventure of the Six Napoleons" we have the systematic smashing of a mass-produced bust of the emperor. The villain is only trying to recover a black pearl of the Borgias hastily embedded in the wet plaster of one of the busts when it was on the assembly line, but for us the symbol remains as a detail of the iconography of still life being canceled by violence, and we want to know why. "A plaster bust of Napoleon, which stood with several other works of art upon the counter, lying shivered into fragments," runs the text. That "shivered into fragments" is interesting: classical art had for a century been appearing in fragments in museums and collections. Fragmentation was the very condition of the past. A debate maintained as to whether the fragments should be put back together with wax, as the Romans did, and as the eighteenth century had taken up.

Or was there some poignant eloquence in leaving the fragments in their ruin? From Winckelmann, who was writing a study of the torso of an athlete when he was murdered in 1768, to Rilke's "Archaic Torso of Apollo" we can trace a preference for the broken statue (as Ezra Pound in his "Papyrus" was to insist on the meaningfulness of incomplete classical texts as against their restoration).

Rilke's poem is one way of accepting this broken statue:

> Although we never knew his lyric head
> from which the eyes looked out so piercing clear,
> his torso glows still like a chandelier
> in which his gaze, only turned down, not dead,
> persists and burns. If not, how could the surge
> of the breast blind you, or in the gentle turning
> of the thighs a smile keep passing and returning
> towards the center where the seeds converge?
>
> If not, this stone would stand all uncompact
> beneath the shoulders' shining cataract,
> and would not glisten with that wild beast grace,
>
> and would not burst from every rift as rife
> as sky with stars: for here there is no place
> that does not see you. You must change your life.

Another way of seeing this archaic Greek torso is Constantin Brancusi's *Torso d'un jeune homme*—which is a highly polished section of tree trunk to which Brancusi has fitted two more, much shorter, sections of the same trunk, as divaricate legs from hipbone to crotch to form a chastely sexless and radiantly pure torso of a boy. Brancusi returned the idea of torso back to its most archaic, as in African carving, where the whole figure is always found in the available volume of tree trunk, referring as well to Cycladic sculpture with its minimalization of form and undetailed gracefulness.

It is indeed odd to find the greatest of modernist sculptors completing the work of an Italian hack artisan in a Sherlock Holmes story, but that is what's happening. We can always trust Conan Doyle, as we can trust Poe. Doyle's sense that sculpture had gone into a terminal etiolation was an accurate one. "This Dr. Barnicot," we read, "is an enthusiastic admirer of Napoleon, and his house is full of books, pictures and relics of the French Emperor." And: "the famous head of Napoleon by the French sculptor Devine, one in his hall in the house on Kensington Road, and the other on the mantlepiece of the surgery at Lower Brixton." The smasher of these busts, when killed, was found to have in his pockets "an apple, some string, a shilling map of London, and a photograph."

Art periodically runs a course into degradation, its symbols exhausted. At such moments art itself announces its need to be renewed. Doyle was a genius of almost preternatural perspicacity. He could feel exhaus-

tion in the symbolic content of an art when all its materials had become bric-a-brac, like the bust of Napoleon, an art that began its life as Pericles and Augustus as *genii loci* on a sacred hearth, or even before that as Terminus and Hermes defining numinous space for the purposes of rite and worship.

The honorific placing of images in the clutter of a Victorian room is the occasion for Holmes's replaying Dupin's trick of following a line of thought and interrupting it with an observation proving his acuity. Holmes breaks in on Watson's thought when he is trying to decide where to hang a portrait of Henry Ward Beecher, which proves to be beside a framed portrait of General Gordon. Watson, humanitarian physician and Victorian liberal, is choosing lares and penates for his hearth. Walter Benjamin, that astute reader of clues, says that "The interior [that is, the furnishings of a room] is not only the universe, but the case of the private individual. To inhabit means to leave traces." He notes that the detective story is born in the nineteenth-century room, seeing the connections between Poe's attention to interior decoration and his invention of the tale of ratiocination.

Has it been noticed that in the names of detectives we can see an attempt to elide the classical world, so patently lost in the industrial revolution, with the green world of nature, and thus effect the fusion that modern art has expressed in so many ways, a coalition of Graeco-roman culture and the organic? Auguste Dupin, first of detectives, sets the formula. The Auguste reflects the new system of first names inaugurated by the French revolution, shelving saints' names for classical,

but it also alludes to an exemplary emperor, coupling it with the pine tree, Dupin. The formula holds in Hercule Poirot, combining hero and pear tree, in Jules Maigret, where beyond the joke of a stout man being named Maigret lies the deeper *maigre* from *macer* from *mala,* apple. In Sherlock Holmes we have a Saxon name meaning "manly" + a kind of oak. An alternate form is "stone + implement," Peter Wimsey (a wimsey is a gimlet); and the reduplicative Perry Mason, "stone + stonecutter." And there's the pseudonym John Le Carré. And John Evelyn Thorndyke.

What's at play here is the aligning of the perspicacious man of popular culture (one who descries, and is all head and brain, the body being comic and weak) with the archaic heroic spirit. This spirit, says art, survives in our time as intelligence. The head as fate takes on new meaning, not as the ancient seat of a noble nature and a stoic rectitude of behavior, but as cunning and intellectual sharpness.

Conan Doyle was not convinced of this: hence all his messages of crushed heads. Poe was not convinced of it either, for the head in "The Fall of the House of Usher" is not on the tabletop but is the house itself. The two meanings of *house,* family and dwelling, combine: and they are at odds or, as we can say now, schizophrenic, of divided mind. This image recurs throughout nineteenth-century literature, in Hawthorne, in the Brontës, and in Melville. When Umberto Eco wrote *The Name of the Rose,* sustaining a critique of Borges and his enigmas, he cast the story as a plot by Conan Doyle and chose for his protagonist (who is a medieval Sherlock Holmes) a typical Norman English name, William,

and the name of a house under a curse that is both the family name and that of the estate, Baskerville.

The bust on the tabletop, then, is an emblem of a new fate. When Charles Olson disapproved of the derivative poetic style of Rainer Maria Gerhardt "as signs worn / like a toupee on the head of Poe cast / in plaster" (and he was perhaps thinking, when he said this, of Charles Ives's piano with its bust of Wagner wearing his Yale baseball cap), he was making a symbol of the artificial as a mask or defect, or a prolongation of symbol beyond its power to communicate.

An example. Back before the measure of time in Olympiads, the willow tree spirit, Orpheus, whose singing could tame animals and could even penetrate into matter and move rocks and trees, lost his wife Eurydice (or Agriope) to the bite of a serpent. He followed her soul to the realm of the dead, opening his way there with the magic of his music, and charmed Hades into returning her to him. Hades made the stipulation that Orpheus should not look back to see if Eurydice was following. He looked back as soon as he was out of the underworld, but Eurydice was not. He thereafter loved boys rather than women, for which he was torn asunder by Thracian Maenads. His head, singing, floated down the Hebros River, to the island of Lesbos, where it was hung in a temple, and became one of the oracles.

Poe recasts this myth as "The Fall of the House of Usher," transposing it to his gothic mode. In doing so he constructed a twin set of symbols to complement his own myth of an Islamic angel, Israfel, "whose heart-strings are a lute." Orpheus's lyre and Israfel's lute re-enter West-

ern poetry with Poe in a tension of what Spengler would call Faustian and Magian cultural styles. The myth of Orpheus itself was drained of significance for Poe, whose concern with his inverted Orpheus-Usher and his angel Israfel was the transience of beauty and the ability of art to fix that transience in an immortal sign.

Three stylistic modes, or associative kinships of symbols, function like musical keys in all Poe's work. To this organizing harmony he draws attention in titles, adjectives, and characteristic sets of images proper to each mode, to which he assigned the names arabesque, gothic, and classical. By arabesque he meant the cultural idiom of Islam, its curvilinear calligraphy and intertwined convolutions in the design of its carpets, its predilection for the musical and verbal over the pictorial, its abstract spirit expressed in astronomy and mathematics. In some sense, what Poe called arabesque is his emotional analogue for Judaism, which his religious neutrality found uncomfortable. The arabesque is Poe's idiom for an intense spirituality, as in his early poem "Israfel" (but note how that word both conceals and shows *Israel*), and for personal beauty combined with intellect, as in his soulful and fated women who seem to be Barbra Streisand with Einstein's brains.

To the arabesque Poe assigns an accomplished sensibility, acumen, speculative thought, sensuality, and cunning. It is the eternal sun of Arabia and the mathematical starlight of Byzantium under the Caliphate.

By gothic, he meant "the Germany of the soul," neurasthenia, melancholia, a rationality tragically disposed toward superstition and the supernatural (while intelligently exploring the archaic feeling that all

matter is alive and perhaps sentient), the willfulness and hubris of Faustus, the turbulent soul of Hamlet, the bleak autumnal weather of "Ulalume," "The Raven," and "The Fall of the House of Usher." It is the mode we have traditionally, if wrongly, assumed to be Poe's dominant one, the one that Europe focused on in its connoisseurship of Poe: the one that has, so to speak, gone public.

By classical, Poe meant "the glory that was Greece and the grandeur that was Rome," the received Hellenistic cliché in all its Byronic, Shelleyan, and Keatsian masks, almost wholly expressed in the classical bust, the Corinthian column, a vague notion of Homer, Anacreon, and Sappho, Alexander's profile on a coin, Plato's ideality and Aristotle's universal attention as the bedrock of Western thought.

The arabesque, then, is exotic, the gothic sinister, the classical noble. That these symbolic idioms correspond to Spengler's division of cultures into Magian, Faustian, and Apollonian may mean that Spengler read Poe, like Baudelaire, Mallarmé, and Valéry, with a greater imaginative intensity than Americans have ever read Poe. Or it may mean that in the unwritten geography of the imagination Fernand Braudel asks for in his study of the Mediterranean we will discover that the northern shore of the Middle Sea—from Barcelona to Ephesus along a fractal coast that laces in Italy, Crete, Sardinia, and Sicily—is of a piece in its poetic configuration of the world, and constitutes Poe's classical and Spengler's Apollonian culture; and that the southern coast from Istanbul to Tangier, with a gathering inland to the east of Turkey, Persia, and Arabia, is Poe's arabesque and Spengler's Magian. There are rich confusions at both

ends, so that the Alhambra, thanks to Washington Irving, was quintessentially Spain for Poe, as Athens in a Turkish zamindari was his quintessential Greece. Poe's gothic realm, like Spengler's Faustian, is not northern Europe (which for Poe was the land of maelstroms and for Spengler the perspectiveless steppes of Russia) but the upper boundary of the Roman Empire, where Poe's own heritage was shaped for transfer to North America.

Somewhere in a deep forest, reached by roads bringing books from Venice, a guitar from Spain, oil paints from the Netherlands, sits the House of Usher.

Poe more than any other writer was keenly awake to the thin lines of vital communication flowing into the new world. His forty years of life are coterminous with Lincoln's and Darwin's first forty years, between Beethoven's Fifth and Verdi's *Macbeth,* from Napoleon's abolition of the Inquisition in Spain and Italy to the Roman republic under Mazzini, and yet those years seem to us to have been spent in a kind of dream that fed on poetry and popular articles on science in magazines—a creative mind that worked with hearsay, rumor, and fierce speculation.

"The Fall of the House of Usher" is in its dominant mode gothic: German Romanticism as anglicized and transformed by Scott, Coleridge, and Matthew Gregory Lewis. But it is written over and in counterpoint to the myth of Orpheus and Eurydice, with an arabesque hypersensitivity and fantasia playing over the whole.

The name Usher derives from either the Old French *ussier,* a doorkeeper, or *osier,* a willow tree. Either way a link connects it with

Orpheus, whose name means willow, and whose fate was in doors he could open but not re-enter; whose harp, like the one on the epigraph, was suspended, along with his head, in a temple of Apollo; who could reach the sentience in stones and trees with music, and who brought a beloved back from the dead.

In the still center of the story, beyond the periphery of German winds, rotting lichen, insecure stone, and metallic Hades below, Poe has placed a tabletop, with objects.

A tabletop in its own intimate space, a musical instrument that has been put aside for a moment, a book or sheet of music, a newspaper, a pipe, a bowl of fruit, a bust, usually classical: such is the traditional still life for the past five hundred years. The musical instrument displays versatile affinities from age to age. Most archaically it is Orpheus's lyre, as the bust is archetypally a mask of Dionysus at the origin of drama. The two together are actor and music summoning the dead to speak for a while on stage. By the Renaissance, the musical instrument had joined objects emblematic of the pleasures of the five senses.

Still life, positing that there is a space in a civilized house where one reads, eats, sips wine, plays music, converses, is in an unbroken tradition from the classical dinner floor that was the household's place for conviviality (Plato's Symposium, Christ with his disciples in the upper room, Plutarch's comfortable house in Boeotia) through the medieval studium (scholar or saint among his books, with lion).

Poe arranged the still life of "many books and musical instruments" on Usher's library table with a full sense of the tradition of still life avail-

able to him. As in a Zurbarán, the surrounding space is a darkness in which objects gleam with a Rembrandtesque light. We can make out in this room draperies, antique furniture, and paintings in the manner of Fuseli that do not open the room out with vistas like a Canaletto or Turner, but turn it back on its claustrophobic airlessness.

The books, "which, for years, had formed no small portion of the mental existence of the invalid," and which have been topics of discussion during the narrator's visit, are listed in a catalogue that is meant to be enchanting, mystifying, and suggestive of Usher's rare intellect and dark imagination. These books are:

1 • "The Vertvert et Chartreuse of Gresset"; that is, the comic narrative poem "Vert Vert" (1734) by the Jesuit poet, playwright, and critic Jean-Baptiste-Louis Gresset (1709–1777), and his satiric poem "La Chartreuse," a witty description of life in the monastery pointed enough to get him expelled from the Jesuit order. "Vert Vert" is about a parrot so named, who has been taught to say Ave Marias and Pater Nosters so prettily in a nunnery that a bishop, hearing of this wonder, commands Vert Vert to be sent to him on a visit. He travels in a cage on a canal boat, where he learns new phrases, so that what the bishop hears is not Ave Marias but the pungent exchanges of bargemen, and is sent home in disgrace. One is changed by travel; experience colors.

2 • "The Belphegor of Machiavelli," a novella (1515) in the manner of Boccaccio in which "a fallen archangel comes to earth to investigate the

complaints of many souls that their wives are to blame for their damnation. In Florence, well supplied with money, [Belphegor] marries the beautiful Onesta Donati, who fleeces him so that he must run away from his creditors. He 'possesses' three ladies in succession, and finally, hearing that his wife is coming after him, he returns to Hell." In English literature we know this plot in a more hilarious version as that of Ben Jonson's *The Divel Is an Ass*. Poe is counting on Machiavelli's evil reputation and the Miltonic sound of Belphegor to create a sinister aura around this comedy.

3 • "The Heaven and Hell of Swedenborg." This is *Concerning Heaven and Its Wonders, and Concerning Hell; from Things Heard and Seen*, by Emanuel Swedenborg (1688–1772), the basic theological text of the Church of the New Jerusalem, or Swedenborgian Church, wherein we may suppose that if Poe had read this work at all he was most interested in paragraphs 87 through 115, in which Swedenborg outlines the mystical correspondences between things celestial and earthly. This is the first of Usher's books that doesn't sound like Poe manipulating our supposed ignorance. And this is the book through which flows the medieval doctrine of correspondences that passed on to Blake, Baudelaire, Fourier, and, most successfully, Joyce.

4 • "The Subterranean Voyage of Nicholas Klimm by Holberg"— Ludvig Holberg, the Dano-Norwegian humanist and founder of modern Danish literature. His *Nicolai Klimii iter subterraneum* (Leipzig, 1741)

was translated into English as *Journey to the World Underground* in 1742, with four more editions until 1812, and thereafter forgotten. Holberg is an engaging imitator of Montaigne, but a feeble emulator of Swift's *Gulliver's Travels* and Montesquieu's *Lettres persanes*. *Niels Klimm,* as the Danes know this little satire, is a fantastic account of a world inside the earth, with talking trees and other alternate creations, with a message of tolerance and understanding of differences among religions. We may be grateful that it inspired Jules Verne's *Voyage au centre de la terre,* enforced Poe's fascination with the interior world of John Cleves Symmes, the hollow earth theorist from Ohio, and gave us Tolkien's Ents.

5 • "The Chiromancy of Robert Flud, of Jean D'Indagine, and of De La Chambre," that is, three treatises on palmistry, Robert Flud's *Tractatus de Geomantia* (1637), Johannes ab Indagine of Steinheim's *Introductiones Apotelesmatici . . . in Chiromantium* (1522), and Marin Cureau de la Chambre's *Discours sur les Principes de la Chiromancie* (1653). Poe took these books from Jacob Friedrich, Freiherr von Bielfeld's *Les premiers traits de l'érudition universelles, ou analyse abrégée de toutes les sciences, des beaux-arts et des belles lettres* (3 vols, Leiden, 1767). Or, as much to say, if fate is written on our hand, what has head to do but gaze and listen?

6 • "The Journey into the Blue Distance of Tieck"—Ludwig Tieck's *Das alte Buch und die Reise ins Blaue hinein* (1834), in which "a mediaeval

noble . . . marries Gloriana, the Faerie Queen. She reigns in a paradise inside a mountain, where dwell the souls of great poets—Dante, Chaucer, Shakespeare. Ugly gnomes have taken over authors like E. T. A. Hoffmann and Victor Hugo, but an emissary of Gloriana embraced the young Goethe."

As in Poe's note to assure us that great minds other than Usher's have seriously considered "the sentience of all vegetable things," which we must restore from "Watson, Dr. Percival, Spallanzani, and especially the Bishop of Llandaff.—See 'Chemical Essays,' vol. v." to "Richard Watson, Bishop of Llandaff, *An Essay on the Subject of Chemistry* (1771), vol. iii of his *Chemical Essays* (5 volumes, 1787); Abbé Lazzaro Spallanzani's *Dissertations Relative to the Natural History of Animals and Vegetables* (London, 1784); and Dr. Thomas Percival on the perceptive power of vegetables in *Memoirs of the Literary and Philosophical Society of Manchester* (5 vols., London, 1785–1802, vol. ii, page 114)," there is a strong element of Romantic tushery in the catalogue of Usher's books. Scholars suspect that Poe's knowledge of the books came from secondary sources, and that the list is a conjuring trick.

7 • Campanella's *City of the Sun* is not about a city in the sun, as Poe's great editor Thomas Ollive Mabbott tells us (under the spell of Poe's magic), but about a utopia along the lines of More's, and much duller than More's in its daily affairs. Poe wants us to believe that this tepid and turgid Renaissance dialogue about political sanity is a gorgeously

exotic fantasy. He wants us to imagine that the "Vert Vert" of Gresset is rich and strange. He hopes that "the Belphegor of Machiavelli" suggests a text of Marlovian grandeur and sinister evil. Many a student has fallen asleep trying to read Swedenborg's *Heaven and Hell,* and special talents in curiosity are needed to find seventeenth-century treatises on palmistry interesting. As for the *Vigiliae Mortuorum secundum Chorum Ecclesiae Maguntinae,* "The manual of a forgotten church," Poe outdoes himself in passing off an ordinary and innocuous breviary as a gothickly strange text full of rites both forbidden and shocking.

Poe charms us with his still life of Usher's books, much as a snake charms a bird, or as the illiterate assumed in the Middle Ages that texts are spells to mesmerize and bind, that grammar is its folk derivative *glamour.* The charm, historically, was efficacious. Writers of science fiction have been trying to write books as charged and galvanic ever since. If the "Vert Vert" is not a romance in the greenest of jungles, W. H. Hudson's *Green Mansions* is; Jules Verne's *Voyage au centre de la terre* fulfills the prophecy of "the Subterranean Voyage of Nicholas Klimm by Holberg." Tolkien gave us what Poe had hoped "the Journey into the Blue Distance of Tieck" was in his imagination, and H. G. Wells, H. P. Lovecraft, Arthur Machen, and many another have offered books at Poe's behest that Roderick Usher would display on his library table.

The passages in Pomponius Mela's *De situ orbis* "about the old African Satyrs and Oegipans, over which Usher would sit dreaming for hours" can be found. One is at I, 8, and reads: "The Satyrs have noth-

ing save the form. The form of the Aegipans (goat-pans) is as they are named."

That the phrase "African Satyrs" would have an equivocal meaning for Poe the Virginian—raised among black slaves who slave owners feared might revert to savagery any moment, and who Louis Agassiz believed were a species separate from *Homo sapiens,* having nothing human save the form—is a dimension of Poe's psychology that turns up in the orangutan of "The Murders in the Rue Morgue" as well as in the reversal of keeper and kept in "The System of Doctor Tarr and Professor Fether," as Harry Levin has shown in his seminal study of Poe's themes in his *The Power of Blackness.*

Another passage in Pomponius Mela is at III, 95:

> The fields, as far as they can be seen, are those of Pans and
> Satyrs. This opinion is held because, although there is no trace
> of cultivation therein, no house of inhabitants, no pathways,
> a solitude vast by day, and a vaster silence, at night frequent
> fires gleam, and as if camps widely spread are indicated, cym-
> bals and drums resound, and flutes are heard, sounding more
> than human. [Mabbott 1978: 421]

Usher in his German fastness sits and imagines fauns and satyrs. The gothic dreams the classical, with arabesque sensuality. Art communicates spirit to spirit, with tone controlling what is meant. It is worthwhile looking at Usher's satyrs, in which he saw the pastoral, Theocritian anti-

world of his cerebral existence, as they will be envisioned by one of his literary descendants, Stephen Dedalus:

> A field of stiff weeds and thistles and nettlebunches. Thick among the tufts of rank stiff growth lay the battered canisters and clots and coils of solid excrement. A faint marshlight struggled upwards from the ordure through the bristling grey-green weeds. An evil smell, faint and foul as the light, curled upwards sluggishly out of the canisters, and from the stale crusted dung.
>
> Creatures were moving in the field; one, three, six: creatures were moving in the field, hither and thither. Goatish creatures with human faces, hornybrowed, lightly bearded and grey as indiarubber. The malice of evil glittered in their hard eyes, as they moved hither and thither, trailing their long tails behind them. A rictus of cruel malignity lit up greyly their old bony faces. [Joyce 1916: 137–38]

These foul creatures are the same beings who cavort in Poussin, Titian, and Picasso as sprightly allegories of procreative energy. They are the daimons Picus and Faunus of the Aventine Hill that Numa Pompilius consulted to learn the Roman charm against thunder and lightning that was still used in Plutarch's day.

Stephen Dedalus's satyrs are Augustinian: devils from the pagan world. Roderick Usher's are as ambiguous as all the themes in "The Fall

of the House of Usher," ambiguous and ambivalent. Poe's is the art of the indistinct distinctly drawn, a rational voice saying that where reason sleeps, monsters breed. But he is fascinated by monsters.

Usher's neurasthenia, which would receive Jean-Martin Charcot's medical attention thirty years later, and Sigmund Freud's psychiatric attention seventy years later, is the stagnant selfishness into which a habitual introversion must deteriorate. The classic diagnosis, before Poe, was that of Robert Burton in 1621:

> Generally thus much we may conclude about melancholy: that it is most pleasant at first, I say, a most charming illusion, a most delightsome humor to be alone, dwell alone, walk alone, meditate, lie in bed whole days, dreaming awake as it were, and frame a thousand fantastical imaginations unto themselves. They are never better pleased than when they are so doing, they are in paradise for the time, and cannot well endure to be interrupt; with him in the Poet,
>
> > *By Pollux, friends, quoth he,*
> > *You've slain, and not befriended me!*
>
> you have undone him, he complains, if you trouble him: tell him what inconvenience will follow, what will be the event, all is one, the dog returneth to his vomit, 'tis so pleasant, he cannot refrain. He may thus continue peradventure many years by

reason of a strong temperature, or some mixture of business, which may divert his cogitations; but at the last a wrecked imagination, his phantasy is crazed, & now habituated with such toys, cannot but work still like a fate; the Scene alters upon a sudden, Fear and Sorrow supplant those pleasing thoughts, suspicion, discontent and perpetual anxiety succeed in their places; so little by little, that shoeing-horn of idleness, and voluntary solitariness, Melancholy, this feral fiend, is drawn on, and as far as it reaches its branches toward the heavens, so far does it plunge its roots to the depths beneath; it was not so delicious at first, as now it is bitter and harsh: a cankered soul macerated with cares and discontent, a being tired of life, impatience, agony, inconstancy, irresolution, precipitate them unto unspeakable miseries. [Burton 1927: 346]

Poe's invention of the neurasthenic and hypersensitive Roderick Usher is both a refinement of a melancholy temperament studied from Aristotle to Robert Burton and the genesis of a type, the man of abnormally acute senses, sensitivity, and sensibilities. He has no body; he is all head. His morbidity subtracted and his sharpness of eye and analytical genius directed toward the common good, Usher becomes César Auguste Dupin, who became Sherlock Holmes, who became Stephen Dedalus, in whom all the traits of the type return: Hamlet's medieval remorse and Renaissance hauteur, Dupin's French pedantry, Holmes's acumen and depression alternating with a poetic lucidity.

Joyce made this type dissolve before our eyes, replacing it with a man possessing a body and a brain, Leopold Bloom.

But before Joyce could act, the head as a symbol of fate had gone through a great decadence. Myth is full of decapitations: Orpheus, the Gorgon at the hands of Perseus, Goliath at the hand of David, Sisera at the hand of Jael. The tragic pity of a decapitation caught the Romantic eye, and figures in Keats, but the return of the theme to European literature happens in Stendhal's *The Red and the Black,* where the romantic antihero Julien Sorel suffers decapitation with all the horror of a new Orpheus. Forty years later, Flaubert retold the story of John the Baptist, with its famous last sentence, where matter-of-factness and accuracy of perception announce a new kind of sensibility in European prose—"As the head was heavy, they took time about carrying it."

This powerful story created a cult of John the Baptist in fin-de-siècle iconography. Gustave Moreau took it up with morbidity and conscious artificiality—painting in a style that Paul Gauguin called "jewelled snot." Joris-Karl Huysmans took up Moreau, and Wilde took up Flaubert, Huysmans, and Moreau. His *Salomé* completed the cult's strange transformation into an erotic fantasy. Aubrey Beardsley made illustrations to Wilde that are better known than the play (though Wilde's tomb by Jacob Epstein in Père Lachaise is inscribed THE AUTHOR OF SALOMÉ) and Strauss set Wilde's play as an opera better known than either. We must note that Beardsley treats John's head on its platter as a still life, and includes among his illustrations many Usher-like collections of books. Something has come full circle: from Orpheus to Richard Strauss, a grand

chord, or a trajectory moving from a springtime to a decadence and a cancellation of itself.

Man, when we first see him configured in art, is a whole body. His fate is in his running legs and versatile hands, in his sexual organs and in his kinship to animals. The hunter in the neolithic cave at Lascaux is a mere stick figure among splendidly drawn animals. He has killed a bison with his spear. He is ithyphallic, and his head, or mask, is that of a bird, who is depicted again, nearby, mounted on a staff. This feeling that man can succeed as a hunter by magically incorporating the spirit, more privileged and luckier than his, of bird or lion, persists in the mask, in Egyptian zoomorphic gods, in the Roman eagle and Hunnish crow that preceded armies into battle, in standards and insignia. From Lascaux to the British lion, more than thirty thousand years, there is an unbroken tradition. The grasshopper of the Golden Horde out of China became the Frankish fleur-de-lys (misread by the British as a frog) and by an alternative evolution Napoleon's industrious bee, the Boy Scouts' lily, and, at a guess, the Canadian maple leaf.

The emergence of the head as mankind's fateful symbol happened by way of the animal. The graceful bust of Nefertiti that has come down to us (and which an archeologist, puzzled by so early an example of a portrait bust, kept hidden for years) is a selection by its sculptor from many possibilities. Nefertiti could plausibly have been represented with a cow's head, as Hathor, or a lioness's, as Sekhmet. The astonishing thing is that it is a bodiless head, a reversion to the mask, as well as a new direction. It is uncomfortable and discouraging to think of the helmeted

bust of Pericles in the British Museum (the helmet hides his enormously long cranium that gave him the name Old Squidhead in his day, as Plutarch tells us) as being in a category with Haida masks, heads lopped off by Assamese Nagas to make the rice grow, or even the melancholy skulls of memento mori, but the connection is as obvious as it is instructive.

What we accept and honor in this tradition is the Roman ancestral bust. We use it on coins, on postage stamps, and for the display of virtue in public buildings, libraries, and private homes. Bourdelle's bust of Beethoven proved to be the most popular of his works, and the humble distribution of busts of Liszt and Wagner on a million pianos in a million middle-class homes is witness enough to our allegiance to the detached head as a symbol of what we think we are and what we're up to. We have discarded the classical herm, a bust on a shaft where genitalia were included as integral to the person. We accept the full body in sculpture, or the bust. The torso is a body, not a person. Christ's praying hands have not inspired portrayals of other hands. Why do we not have a sculpture of Pasteur's cunning and Wanda Landowska's miraculous fingers, Pavlova's feet? No: tradition is tradition. The head, as still life maintains, is our fate. Years before he included it in the *Guernica*, Picasso also painted a classical head among books and musical instruments, architectural drawings, and a tablecloth with a Greek design along its border, reasserting ancient symbols in their proper place. In the *Guernica* this same head lies broken on the ground, amidst the violence of war.

After the war, and at the terrible disclosure of the death camps, Picasso attempted to respond to the Holocaust. Strangely, he chose still life as his genre, with bound, emaciated corpses lying below a tabletop with pitcher, bread knife, and bread. Though this painting went through several revisions, he left it unfinished.

III

APPLE AND PEAR

Apple and pear are, as Samuel Butler said of the *Iliad* and *Odyssey*, husband and wife. The oldest of cultivated fruit trees, they cling together as a formulaic phrase, whether in fifth-century Greek or the journals of Thoreau, and as complementary symbols in classical poetry and prose. Their togetherness has remained a doublet of images in the long history of still-life painting.

Odysseus, revealing his identity to his father, Laertes, began the inventory of his inheritance with thirteen pear and ten apple trees. Athenaios, who tells us that there are no apples more delicious than those

grown near Aquileia in the Alps, records that the Spartans set out apples and pears for the gods at the festival of the Theoxenia.

The Argive plain was once called The Field of Wild Pears, back before the foundation of Mycenae. Children, as late as the time of Hadrian, had a dance in which they threw pears at each other and sang

> Green pear, ripe pear,
> Pear chuckers, we!
> Pears flying everywhere
> Under the tree.

From the Middle Ages through the Renaissance, painters included apples and pears with madonna and child—apple symbolizing the fall, pear the redemption. Caravaggio puts a still life of apples and pears in a *Supper at Emmaus*. Picasso painted apples and pears for seventy-five years. Balthus, in *The Painter and His Model* (1982), summing up his career in a self-portrait from the back, with a model kneeling to look at a sketch on a chair, places on a table behind them a basket of apples and pears.

Apple is bonded with pear throughout Greek erotic poetry. In Longus's *Daphnis and Chloe* they function after a thousand years of tradition with the same lissome articulateness as in the poetry of Sappho and Anacreon. Daphnis, having obtained Chloe's hand from her father, Dryas,

forthwith, staying neither to eat nor drink, ran to where Chloe was milking her ewes to make cheese, and told her of their marriage soon to be, and kissed her boldly, before all the world, as his own, and worked beside her, milking ewes into a pail, carrying the milk to the dairy, putting strayed lambs back with their mothers, and tending his goats. And when he had seen to all this, they bathed, ate, drank, and went to pick ripe fruit, of which there was a great abundance, as August was at an end, and autumn was in its fullness. The orchard was laden with wild pears, medlars, and quinces. Some had fallen, and were more fragrant, smelling like wine, than those still on their branches, which shone like gold.

One apple tree, already picked and bare of leaves, kept one apple on its topmost bough, which, for all its being sweeter and larger than any other, the pickers had not dared to climb so high for, nor had they been able to shake it loose. Surely so lovely an apple had held on for a shepherd in love. No sooner had Daphnis seen it than he wanted it for Chloe, who was fearful of his climbing to get it. Nevertheless, as soon as she left to tend her flock, he climbed the tree and brought her the apple. She was alarmed that he had risked the climb, and Daphnis, to quiet her, said, "This apple, my love, was born in summer's brightness, nursed by a beautiful tree, ripened by the autumnal sun, and guarded by fate for us. I

would have been blind not to see it, and a fool, having seen it, to leave it there, to fall and be trampled by goats, or poisoned by a grazing snake; or, if it had not fallen, to wither in the weather. Was not Aphrodite given an apple for her beauty? That prize is now yours. Her apple was given her by a shepherd, yours by a goatherd." So saying, he put the apple into her dress, between her breasts, for which she kissed him so tenderly that he had no regret of climbing so high for an apple more precious to him than if it were made of gold.

In Theocritus's Idyll VII, a shepherd sings:

> Aratos burns in the marrow of his bones
> For a boy.
> O Pan romping in the meadows
> Of Thessaly, make that boy want to climb
> Into Aratos's arms, Philinos if you will,
> Though any other boy will do as well.
> Comply, Great Pan, or be beaten with squills
> On your legs and back by Arcadian boys,
> Refuse, and I hope you get tangled in briers
> And sleep in nettles, and be in Thrace
> In the middle of winter, in the mountains,
> And in Africa, among the rocks, in summer,
> Far from the Nile.

And you, Cupids, ruddy
And bright as apples all, leave blond Dione's
Springs at Hyetis and Byblis and Oikous
And open fire upon Philinos the stubborn
With your magic arrows.
O! the women say,
He is as sweet as the mellowest pear,
But handsomeness will pass away.

Further along, in this same idyll, we have this description of a day's end:

On vineleaf beds fragrant with mastic gum
We lay, happy, under the thick shade
Of black poplars and elms near a ruckling spring.
In this cool dark crickets chirped, tree frogs rasped,
Doves cooed through the trilled songs of lark and finch,
And a fuss of bees thrummed around the spring.
All was fattened summer ripening into autumn.
Pears lay at our feet, and apples dropped beside us.
And plums bent their bushes to the ground.

In Greek and Roman pastoral, a gift of apples is a declaration of love. Listen to this Virgilian, Theocritian theme in New England in the nineteenth century. Thoreau (who translated Anacreon), his journal entry for 10 June 1855:

What if I feel a yearning to which no breast answers? I walk alone. My heart is full. Feelings impede the current of my thoughts. I knock on the earth for my friend. I expect to meet him at every turn; but no friend appears, and perhaps none is dreaming of me.

(Three weeks and three days after Thoreau wrote these lines in Concord, a book called *Leaves of Grass,* ninety-five pages long, with the author's name given only in the copyright notice, was on sale at Fowler and Wells Book Shop in New York, price two dollars.)

I am tired [Thoreau continues] of frivolous society, in which silence is forever the most natural and best manners. I would fain walk on the deep waters, but my companions will only walk on shallows and puddles. I am naturally silent in the midst of twenty from day to day, from year to year. I am rarely reminded of their presence. Two yards of politeness do not make society for me. One complains that I do not take his jokes. I took them before he had done uttering them, and went my way. One talks to me of apples and pears, and I depart with my secret untold. His are not the apples that tempt me.

No friend *appears*: the word is a fusion of *apple* and *pear.* Apple tempts, pear reconciles. Apple, for Thoreau, is objective, public, social.

Throughout the fourteen years of his journal, we find him meditating on apples both as a botanist and as a philosopher. It has become natively American. Of pears he is not certain; they will not drop their European aura.

Thoreau, his journal entry for 11 October 1860 (while parliaments with very different fates were sitting in Montgomery and Turin):

> The season is as favorable for pears as for apples. [Ralph Waldo Emerson's] garden is strewn with them. They are not so handsome as apples—are of more earthy and homely colors—yet they are of a wholesome color enough. Many, inclining to a rough russet or even ferruginous, both to touch (rusty) and eye, look as if they were proof against frost. After all, the few varieties of wild pears here have more color and are handsomer than the many celebrated varieties that are cultivated. The cultivated are commonly of so dull a color that it is hard to distinguish them from the leaves, and if there are but two or three left you do not see them. . . . Yet some have a fair cheek, and, generally, in their form are true pendants, as if shaped expressly to hang from trees.
>
> They are a more aristocratic fruit. How much more attention they get from the proprietor! The hired man gathers apples and barrels them. The proprietor plucks the pears at odd hours for a pastime, and his daughter wraps them each in its paper. . . . They are spread on the floor of the best room.

They are a gift to the most distinguished guest. Judges and ex-judges and honorables are connoisseurs of pears, and discourse of them at length between sessions. I hold in my hand a Bonne Louise which is covered with minute brown specks or dots one-twelfth or one-sixteenth of an inch apart, largest and most developed on the sunny side, quite regular and handsome, as if they were the termination or operculum of pores which had burst in the very thin pellicule of the fruit, producing a slight roughness to the touch. . . . If the apple is higher-colored, reflecting the sun, on the duller surface of this pear the whole firmament with its stars shines forth. They whisper of the happy stars under whose influence they have matured.

Pears, it is truly said, are less poetic than apples. They have neither the beauty nor fragrance of apples, but their excellence is in their flavor, which speaks to a grosser sense. . . . Hence while children dream of apples, ex-judges realize pears. They are named after emperors and kings and queens and dukes and duchesses. I fear I shall have to wait till we get pears with American names, which a republican can swallow.

Thoreau's feeling that the apple had become a naturalized American while the pear remained European bears inspection. Apple—prize, temptation, reward—is a symbol containing opposite meanings: love and hate, harmony and discord. Pear is wholly charismatic; moreover, when

it displays double meanings like the apple, the meanings are both benign. Indeed, in the pear we have a focus of natures blended. In Sparta the pear tree was sacred to Castor and Pollux—images of these twins were hung in its branches, and by sacred edict all images of their sister Helen were made of pearwood. If there are negative connotations to the web of symbolism around the pear, they come from Helen. Castor and Pollux became the protectors of sailors. Static electricity playing in the rigging of a ship is, if double, a sign of fair weather, and was called The Double Dicks by sixteenth-century sailors, *corposanto* in the Mediterranean languages; but if single, it is St. Elmo's fire, Helen's fire, and means stormy weather. From the *genii* of the Spartan pear tree we can move into many complex myths; one will take us through the zodiacal sign Gemini to their shrine in Spain at Santiago de Compostela, where Castor and Pollux have become Jesus and his brother James, and along this line the pear as the symbol of Christ's redemption may well run.

Pear symbolizes a harmony between human and divine; apple an encounter between human and divine. The forbidden fruit in Eden became an apple through linguistic accident, punning on *evil* and *apple*. But the inevitability of the accident was ensured by centuries of Greek and Latin pastoral poetry in which the apple was eroticized.

Paul Cézanne, by any reckoning the progenitor of modern European painting, and one of the greatest masters of still life, and, were it not for Joyce to stand in that place, the archetypal artist of our time, reinvented the apple. The apple had by no means disappeared, as a look at American still life painting in the nineteenth century will show (our painters

shared Thoreau's love affair with the apple), as well as the American cultivation of apples, which became a delicacy in Europe. Cézanne it was, however, who made a motif of the apple, which he painted most usually on a farmhouse kitchen table, on a cloth, as if spilled from a horn of plenty.

In 1968 Meyer Schapiro, in a famous iconographic study, set himself to explain Cézanne's apples, as they seemed innocently beyond the reach of iconographic inquiry that would lead anywhere other than the long traditions of still-life painting. What he discovered was first of all a story. Cézanne, when he was a schoolboy, had been brave enough to make friends with a new student in his school whom all the others had decided was to be excluded, snubbed, ignored. This new student was named Émile Zola. He and Cézanne became fast friends. After Cézanne's brave bucking of school taboo (for which he was beaten up), Zola left a basket of apples on his doorstep. They both loved Virgil's pastoral poetry; the symbolism was clear. Alexis received apples from his suitor Corydon. In Theocritus and Propertius there are presents of apples to friends and lovers. Cézanne's late landscapes with classical figures, which would so influence practically all modern painters, are a return to the pastoral themes he and Zola recited to each other in Aix on long country walks.

It was Zola who encouraged the shy Cézanne to come to Paris. They did not, however, remain friends. Zola, successful, began to find the rejected and luckless Cézanne an embarrassment. He wrote a novel about a painter who was to remain forever unrecognized and misunder-

stood, and thereby hurt and alienated Cézanne. Moreover, and wonderfully ironically, Zola the unconventional found Cézanne's keeping a mistress too unconventional. Cézanne's apples begin around this time. He was, as Meyer Schapiro thinks, making a perhaps unconscious return of Zola's gift of apples. One can easily see these apple paintings as a reconciliation, for many contain pears, along with other symbols—a statuette of Eros, a clock, a resonant sense of peace, the domestic beauty of a country kitchen—that we can read as tranquillity.

One of the paintings deriving from Cézanne's pastoral landscapes with nudes (those "Poussins painted from nature") is Picasso's *Demoiselles d'Avignon*. Volumes and planes indicate human bodies. There is a great energy of expression. But where Cézanne had been in search of geometric form and a prismatic shimmer of light, Picasso has gone another step: into primitive form that combines Cézanne's eye with that of medieval and African visual idiom.

Picasso's *Demoiselles d'Avignon* is not merely famous, for fame approves: the painting is decidedly notorious. It is the first canvas of Picasso's to assume a life of its own. He did not think much of it, and had put it away until the time came when everything he painted was interesting to somebody. A misunderstood or bowdlerized remark gave it a title, which should accurately be "The Ladies on the Rue d'Avignon," that is, prostitutes at a brothel on the rue d'Avignon. Indeed, the prototype of this composition would seem to be photographs and sketches of the kind Toulouse-Lautrec and Edgar Degas made of unlovely whores in all the shamelessness of their vulgarity posing in the

bordello parlor, two of them with arms behind their heads, two gesticulating, or stretching, one seated. The drawing is expressionist and schematic. The face of one *demoiselle* is archaic Iberian in modelling, the faces of two others are variants of this style, vaguely medieval, reminiscent of any number of styles well outside Western tradition. The other two faces are derived from West African masks.

We are aware that this painting is a moment of great transition. It is the Stravinsky's *Rite of Spring* of painting, the Apollinaire's *Alcools* of painting. It is in step with Cocteau's advice that unless we periodically put aside our sophistication and listen to the drums of the jungle, we become etiolated. We, like Antaeus, must touch the earth with a naked foot.

And the only other detail in this tribal dance of a painting than the savagely rendered women is a still life of an apple, a pear, a bunch of grapes, and a slice of melon. Four years before, Picasso had drawn a classically regular nude woman seated and holding a bowl of apples. Apple, pear, and a vase of asters became a theme for Picasso still lifes quite early, and he never abandoned them. He kept them through style after style for seventy-five years. One of the things Picasso was doing was sorting through the inventory of the past. It has been the spirit of modernism to do this. Joyce, Stravinsky, Ives, Pound, Zukofsky sifted through world culture as no artists before. Picasso's symbolism is therefore complex in a peculiar way. He never felt the need, as Joyce did, to be an exact tactician in assembling images. He delighted to take the trite and make it fresh and new. The apple, pear, grapes, and melon slice of

the *Demoiselles,* for instance, can be found practically everywhere in still life—in, for example, a Currier and Ives print that hung on thousands of American walls.

Picasso's motifs display a maddening refusal to cooperate with words, though they have inspired many. Eudora Welty began her career with a story, "Acrobats in the Park," that attempted to be a verbal equivalent of Picasso's *Les Saltimbanques,* the painting that inspires Rilke's Fifth Duino Elegy. Gertrude Stein tried to create a cubist prose. And yet Picasso remains nonverbal. Literary and cultural themes flow through him. They are always, however, in competition with images. For all the sources we can point to for the *Guernica,* the basic one is Henri Rousseau's naive painting *War.*

What appears so modern in Picasso is his archaic way of being an artist. He is a contemporary of the painters of Lascaux and Altamira. He is the least modern of artists. So the apple and pear in the *Demoiselles* were put there by sheer whim: which is to say, by accurate intuition. We would need no criticism at all if art were not radically incoherent. The question to ask is not why does Picasso put apples and pears in the *Demoiselles,* as we might successfully ask why Crivelli surrounds the Christ child with zucchini, apple, pear, and cherry, but what does Picasso feel that he paints an apple and a pear. I am going to treat his apple and pear as glyphs rather than images.

In paintings and incised drawings in neolithic caves, the refinement of image into glyph can be seen in figures that are perhaps unfinished but are just as plausibly stopped short because the object can be read as it is.

The line for a horse began at the muzzle and continued along the mane and *mykla,* or dark stripe of primitive equines from head to tail, and it would seem that this cursive was eventually sufficient to graph the idea "horse."

Such glyphs, or graphic shorthand, are always at play in both language and picture, mischievously detaching themselves from their origins. "Jiminy!" says the child ignorant of Castor and Pollux and of any reason for invoking them; we can part brass rags, and give someone the mitten without knowing where the money was coined. All figures of speech fade into vestige.

And now, Picasso's glyphs. He has a propensity in caricature to make the pupil of one eye a spiral and the other a circle with a point in the center. It is an idiomatic gesture of his pencil, and it has a genetic history and a pathology. Picasso has always been attentive to the striking look that heterophthalmia gives to the face. As early as 1903 he painted an old woman with a cast in her eye called Celestina, and throughout his career his habit of combining full face and profile became a stylistic trademark—prompting Henri Rousseau's perfectly accurate observation, "You and I, M. Picasso, are the two greatest living painters, I in the modern manner, you in the Egyptian," the full-face eye in a face seen sideways being the rule in Egyptian drawing.

If, however, we trace these two glyphs, spiral and dotted circle, through Picasso's oeuvre, we find that they occur together much as apple and pear make a symbolic set. Indeed we can discern that the spiral is a pear and the dotted circle an apple. Thereby hangs a pedigree.

In 1831, Honoré Daumier published a famous lithograph entitled *Gargantua*. It shows Louis-Philippe, the bourgeois king, on a cuckstool, being fed by the poor, who are hauling their worldly goods up a ramp into his mouth. He is defecating privileges and wealth for the rich. As an extra insult, the king's head is shaped like a huge pear, with curls and muttonchop whiskers, mocking his mentality and gullibility. French slang, then as now, understands by *poire* a dupe and a simpleton.

For this Rabelaisian caricature Daumier was given six months in prison. To justify Daumier's lithograph, to pay his fine, and incidentally to renew the insult, Charles Philipon, the caricaturist and editor of *Le Charivari* (prototype of *Punch*, the London *Charivari*), published in 1834 a page of four drawings showing a metamorphosis of Louis-Philippe into a pear—as if to say with a rational nicety that nature herself had designed the king as a fathead. The world at this time was interested in reading physiognomies. Johann Kaspar Lavater's *Physiognomische Fragmente zur Beförderung der Menschenkenntnis und Menschenliebe* had come out in 1778, Cesare Lombroso's *L'uomo delinquente* in 1876. "Ce croquis ressemble à Louis-Philippe, vous condamnerez donc?" Philipon's caption asks of the first drawing, and remarks of the second, in which the resemblance to a pear is stronger, "Alors, il faudra condamner celui ci qui ressemble au premier." The third is very pearlike: "Puis condamner pour cet autre qui ressemble au second." And the fourth is a pear pure and simple: "Eh enfin, si vous êtes conséquens, vous ne sauriez absoudre cette poire qui ressemble aux croquis précédens."

"The famous sequence," says E. H. Gombrich in *Art and Illusion,* is the locus classicus for "a demonstration of [the] discovery of like in unlike . . . a kind of slow-motion analysis of the process of caricaturing . . . [that] rests on the plea of equivalence. For which step, it asks [is Philipon] to be punished?"

"Never before," Robert Rey says in his study of Daumier, "have insolence, ignominy, hunger, and vice been more completely fused." And Daumier went on to create M. Macaire and his *avocats* and *juges,* to become the pictorial Balzac of both the poor and their oppressors.

Daumier's savage indignation was taken up in legitimate succession by Georges Rouault and by the tradition of the political cartoon as we still have it. His deliciously satiric genius was inherited by Alfred Jarry, who created the archetypal dunderhead of modern French literature, Père Ubu, the anti-Prometheus and ultimate reduction of Flaubert's Bouvard and Pecuchet.

Jarry's illustrations to the Ubu trilogy derive from Daumier's Louis-Philippe as pear. The same pear-shaped head and the scatological dimension of Daumier's stupid greedy king become for Jarry's pen a spiral of cowflop, or perhaps human excrement.

For the fun of it, Picasso did a series of caricatures of Guillaume Apollinaire for which he appropriated Ubu's pear-shaped head, the cloacal spiral, the whole joke, to create a good-natured private comedy. The glyphs for this comedy, which is a participation in the high jinks of Jarry and Apollinaire at their most spirited, became habitual with Picasso. Not to know Jarry's *Le Surmâle* is to misunderstand the great suite of

drawings Picasso did in the 1950s called "The Human Comedy," as well as the *Trois-cent-quarante-sept gravures* of the late 1960s. These glyphs permeate Picasso's work, pyriform and pomenoid shapes that turn up in the eyes and parts of the body. That is, there is a fantasia of apple and pear in Picasso running beside a prodigious number of still lifes of actual apples and pears.

In a pencil drawing (22 February 1933) of a canvas on an easel and a still life on a tabletop, in a room with window open upon a balcony and fluffy clouds in a pleasant sky, Picasso has drawn a palette hanging on a nail in the wall so that it looks like an apple—the nail is the stem. This punning glyph is repeated in the apple on the table, except that the stem has been enlarged into a phallus. A pear beside it has been worked into a female figure, another pear providing her with a right thigh, a peach giving her a left thigh and buttocks. The apple glyph—circle with dot in the center—appears twice, giving her breasts. Three specks, or freckles, give this pear-woman eyes and mouth. The painting on the easel is neoclassical; everything else is a Picassoid romp of apples and pears.

In January of 1889, Vincent Willem van Gogh painted a *Still Life with Onions* twenty-three days after he had sliced away the lower half of his left ear with a razor, on Christmas Eve. This mutilation and the still life with onions are connected episodes: the one is a meditation on and absolution of the other. Van Gogh was in a neurasthenic rage at Paul Gauguin when he cut away part of his ear. He and Gauguin had shared a studio at Arles since the preceding October, hoping to estab-

lish a French version of the Pre-Raphaelite Brotherhood, which they imagined to be communal. Van Gogh, who had been painting for only seven years, and was at this time doing his finest work, was thirty-five. If he had been able to pass examinations in Greek, he would have had a degree in theology and been a minister in the Dutch Calvinist Church. A sermon that he preached to English coal miners survives. Gauguin was also a refugee in Bohemia from a stockbroker's office. Later, he felt that his two months with van Gogh had been like two months with Edgar Allan Poe.

Van Gogh, for his part, felt that he had been living with the braggart and blusterer Tartarin de Tarascon, and after their break painted Gauguin's chair with a copy of Alphonse Daudet's book on its seat. Neither could cook, as their attempts proved. Gauguin was a nightly visitor to the Tutelle brothel, for the sake of hygiene, as he said. Van Gogh, who had contracted syphilis or gonorrhea in Antwerp, objected. Their physiological theories of sexual indulgence were opposite and mutually exclusive. Gauguin believed, in the folk theory of his time, and of ours, that sexual intercourse was necessary for robust health. Van Gogh, who in a letter to his brother Theo (3 February 1889) mentions in an ambiguous context Dr. Phillipe Ricord (1800–1889), the Baltimore physician and doctor to Napoleon III, who distinguished the two venereal diseases, followed another tradition (which includes Sir Isaac Newton among its adherents) and believed that any emission of sperm diminishes the mind. Van Gogh's prevention against wet dreams was to smear the bedclothes, and himself, with camphor, a panacea that Ras-

pail had promoted and which has vestiges even now in a camphorated liqueur that old-fashioned French folk take as a cordial, and in mentholated cigarettes. When Mary Cassatt was knocked from her carriage in a traffic accident, she treated herself with Raspail's Patented Camphor Rub as a matter of course. Despite its being a poison, Raspail ate a bar of camphor daily, and prescribed it for practically all human ills.

The book in van Gogh's *Still Life with Onions* is Raspail's home medical guide, the first of its kind, a revolutionary book that, like the *Encyclopédie* itself, was a republican wresting of trade secrets from guilds for general dissemination among the people.

Still Life with Onions depicts van Gogh's drawing board mounted on a trestle. The drawing board fills all of the picture space except for a small triangle of tabletop at the bottom, on which sits a bottle of white wine, and, across the top of the painting, the far wall of the room, or a shelf, and its junction with the floor, on which (or on a shelf) sits a large green jug of olive oil, with spout and ear-shaped handle—the Dutch say "the ears of a jug."

On the drawing board, from left to right, we see an onion, a white shallow bowl with two onions, a twist of paper with cheap shag tobacco, of the kind the French call *fort,* Van Gogh's pipe beside it, a thick book, the title of which is painted quite legibly as *Annuaire de la Santé [par] F. V. Raspail,* and there is an onion placed on it, a candlestick with ear-shaped handle (another Dutch *oor*—ear or handle) and a lit candle; a small box of matches, a stick of red sealing wax, with a burnt match across its edge. Then there is an envelope, upside-down in relation to us,

addressed to Monsieur Vincent van Gogh, Postes restantes, Arles (Provence)—*poste restante* because van Gogh had been evicted from "the Yellow House," No. 2, Place Lamartine. Despite van Gogh's broad brush strokes we can, with the help of Billig's *Philatelic Handbook* (vol. 3), identify the postal sigla. The rubber-stamped 67 encircled by three arcs is the postman's mark, applied because this is a registered letter, as we can tell from the *R* in a hexagon. That it has been registered identifies the letter as one from Theo van Gogh in Paris that arrived in Arles on 17 January 1889, containing a fifty-franc note. This letter has not survived. The assistant postmaster Joseph Roulin is well known to us in his blue uniform with gold braid from his portrait by van Gogh (in the Paine Collection, Boston), and his good wife, his fat baby Marcelle, his petulantly handsome older son Armand, and his younger son Camille. If you are a starving artist dependent on money through the mail from an indulgent brother, you cultivate the assistant postmaster and do portraits of all his family.

There are two postage stamps on the letter, one green and one blue. The green is a twenty-centime one of the variety issued between 1877 and 1900. The figure *20* is in red. The only other French stamp with which van Gogh's block of color might be identified is a straw-colored twenty-five-centime one with the figure *25* in yellow. The other stamp on the letter is definitely the fifteen-centime of the same issue, and is the only blue stamp in use at the time. The post office in Paris could have affixed a forty-centime stamp to the letter instead of a fifteen and a twenty-five. There was no thirty-five-centime denomination. So,

unless the bureau had run out of the forty-centime stamp and unless petty exactitude is a new thing in French post offices, the stamps are the blue fifteen-centime and green twenty-centime issues current at the time. The design for both, which van Gogh made no attempt to indicate, was an ornate one: the denomination was in an upright tablet before a globe, to our left of which stood an allegorical female figure wearing a laurel crown and bearing an olive branch. To the right is Mercury in his winged hat and sandals, with the caduceus—peace and commerce.

François-Vincent Raspail (1794–1878), the founder of histochemistry and pioneer in the use of the microscope for studying animal and plant tissues, the analyst of the cell twelve years before Schleiden and Schwann, and the man who some twenty-five years before Pasteur believed, in the face of total doubt among scientists, that disease is caused by "infinitely small parasites," began publishing his *Manuel-annuaire de la santé* in 1845. He considered himself to be another Marat, extending the revolution to the right of people to be healthy, and for the disadvantaged to have their miseries alleviated by an enlightened state. He belongs in social history among those reformers—Charles Fourier, Robert Owen, Étienne Cabet, Saint-Simon—whose vision of hygiene and liberty is now taken for granted, or hoped for, by most of the world. For his idealism, Raspail spent eight and a half years in prison and nine in Belgian exile, sharing that flight of the intellectuals which constituted a refugee Collège de France—rector: Victor Hugo; dean: Edgar Quinet (whose famous paragraph about the persistence of wild-

flowers in meadows while empires rise and fall runs through *Finnegans Wake*); together with a full faculty of displaced persons.

So the appearance of Raspail's medical book in van Gogh's still life is not so much a notation of its importance to his personal health as it is an idealistic flag showing his solidarity with the poor. If we knew nothing of van Gogh's biography, we would assign its meaning to a concern for the potato eaters of his early work. But the meaning is also sharply personal.

Still life was the genre van Gogh used as a kind of visual journal. He painted 194 of them. They are of flowers having some emotional value to him, such as the famous sunflowers, which were painted to welcome Gauguin to Arles, for Gauguin (so he claimed) was part Inca, and the sunflower is also known as the golden flower of Peru. It was the sun in Provence that brought them both there. Van Gogh painted a sprig of digitalis to memorialize a treatment by Dr. Gachet. So the *Still Life with Onions* is first of all a record of sickness and health. The white wine and tobacco are what van Gogh had been living on for weeks before he cut off his ear. Such a diet, along with his disappointment in Gauguin, had made his nerves like hot wires. The pipe begins to appear in Renaissance still lifes as a memento mori: life passes away like smoke. An extinguished candle usually accompanied a pipe, and books and food and musical instruments added up to the vanity of our brief life.

The nineteenth century would transmute these symbols into ones of peace, coziness, and domesticity, until in Picasso and Braque they are

emblems of shrinking privacy, the precious vestiges of harmony in a distracting and insane world.

The onions are as recommended by Raspail's home-treatment manual: the cheapest and most nutritive food for the convalescent. So the olive oil. Are we, however, to read the painting as a promise to do better by way of diet, or as a deeper conversion?

In the onions and tobacco we have Lévi-Strauss's chord from the raw to the burnt. Tobacco and pear ripen after being picked, and both must go through a process of mellowing and curing. Onion, which can be eaten raw, or cooked in many ways, is both food and condiment, and is functioning in this painting as medicine, roles that tobacco and wine have played at various times in history. Onion, then, would seem to be the mediator between wine and tobacco on the one hand and olive oil on the other, that is, between quasi-foods whose effect is on the mind and a nutritious food wholly for the body, even though it is a medium for cooking rather than something to cook. We can analyze these components better if we notice that the picture is about loss and redemption, like all the still lifes of apples and pears, where apple is the fall, and pear the salvation of mankind.

Apple, as Paul Friedrich says in his *Proto-Indo-European Trees,* is the northern European analogue of grape; that is, where grape and wine function around the Mediterranean, apple, cider, and brandy serve the same purpose farther north. The analogue for pear in van Gogh is either the candle or Raspail's book or the letter from Theo, from all of which arises the idea of salvation. So the still life is a permutation of a theme,

with variant and more literal symbols (as how not from a painter who read the Goncourts, Zola, and de Maupassant?). We can go further, and note that *onion* is the same word as *union* by etymology, and this holds in Dutch as in English. The onions, then, functioning as analogue of the redeeming pear, are also apple and pear together, subsuming all the objects in the painting into the one complex symbol.

IV

METAPHYSICAL LIGHT IN TURIN

On 7 April 1888, Friedrich Nietzsche, in Turin and in the last months of any lucidity of mind before the decade of insanity with which his life ended, wrote to his friend and amanuensis, the musician Peter Gast: "But Turin! . . . This is really the city which I can now use!"

This is palpably for me, and was so almost from the start, however horrible the situation was for the first days. Above all, miserable rainy weather, icy changeable, oppressive to the nerves, with humid, warm hours between. But what a digni-

fied and serious city! Not at all a metropolis, not at all mod-
ern, as I had feared, but a princely residence of the seven-
teenth century, one that had only a *single* commanding taste
in all things—the court and the *noblesse*. Everywhere the
aristocratic calm has been kept: there are no petty suburbs; a
unity of taste even in matters of color (the whole city is yel-
low or reddish brown). And a classical place for the feet as
for the eyes! What robustness, what sidewalks, not to men-
tion the buses and trams, the organization of which verges on
the marvellous here. . . . What serious and solemn palaces . . .
the streets clean and serious—and everything far more digni-
fied than I had expected! The most beautiful cafés I have ever
seen. These arcades are somewhat necessary when the climate
is so changeable, but they are spacious—they do not oppress
one. The evening on the Po Bridge—glorious. Beyond good
and evil!

This vision of a nineteenth-century Italian city in transition between
one age and another, keeping its ancient lineaments while gracefully
incorporating electric trams and the railroad, erecting bronze equestrian
statues in its squares and gardens, a city of libraries and learning, would
come to an end for Nietzsche on 3 January 1889, in the Piazza Carlo
Alberto. Here he saw an old draft horse being cruelly beaten. He tried
to defend the horse, embracing it and calling it brother, and in that mo-
ment his mind went dark forever.

When Nietzsche fell, Georg Brandes was giving a course of lectures on him in Denmark. As witness to his collapse, there stood around him the Palazzo Carignano, built in 1680 by Guarini, which had served as the Sardinian Chamber of Deputies in the 1840s and as the Parliament of Italy in the 1860s. In Nietzsche's day it had become a museum of natural history. In front of it stands a statue of a philosopher, Vincenzo Gioberti, whose Ciceronian career had shaped the modern Italian state, whose life had been as public and practical as Nietzsche's had been private and futile. The square also contained a bronze equestrian statue of King Carlo Alberto, together with his palace, which had been made into the Galleria dell'Industria Subalpina.

Before he fell, Nietzsche had come to the conclusion that all history and meaning were arbitrary, a fiction from our minds. All that we could be certain of was that every event would happen over and over again. Character, as Heraclitus had said, is fate; and man in his blindness and with the one unchanging and irredeemable character would stumble forever into the one tragic fate. *The same anew,* as Joyce would say in *Finnegans Wake.*

We have a description of Nietzsche's worktable from this period. Paul Deussen in his memoirs recounts a visit with Nietzsche at Sils-Maria, just before he went to Turin. "The furniture [of his one room] was as simple as could be. To one side, I saw his books, most of which were familiar to me from before, a rustic table with a coffee cup on it, egg shells, manuscripts, toilet articles, all in great disorder, which spread over a bootjack with boots attached, to the still unmade bed."

The beauty of Turin, especially on clear autumn days, occurs in many letters of Nietzsche. A blue sky, he explained, collected his thoughts. He liked the geometry of the city. He saw classical continuities, orderliness, a modern briskness. And the whole was drenched in melancholy and nostalgia.

Nietzsche's vision of recurring fate in Turin was to become the inspiration for the painting of the Greek-Italian painter Giorgio De Chirico. Writing his memoirs in the 1960s, De Chirico remembered trying to get German students in Munich to understand the significance of the streets of Turin in Nietzsche's thought:

> I observed [De Chirico says] that Fritz and Kurt Gatz [though obsessed by the philosophical ideas of Nietzsche] had not in fact understood what constituted the true novelty discovered by [him]. This novelty is a strange and profound poetry, infinitely mysterious and solitary, which is based on the *Stimmung* (I use this very effective German word which could be translated as *atmosphere* in the moral sense), the *Stimmung*, I repeat, of an autumn afternoon, when the sky is clear and the shadows are longer than in summer. . . . This extraordinary sensation can be found (but it is necessary, naturally, to have the good fortune to possess my exceptional faculties) in Italian cities and in Mediterranean cities like Genoa or Nice; but the Italian city par excellence where this extraordinary phenomenon appears is Turin.

And later in these memoirs: "I [began] to paint subjects in which I tried to express the strong and mysterious feeling I had discovered in the books of Nietzsche: the melancholy of beautiful autumn days, afternoons in Italian cities."

De Chirico's early work has entered the sensibility of our time with a success equaled only by that of Picasso in his cubist period. It has, in Valéry's phrase, become part of the permanent furniture of our mind. In a typical De Chirico we see an Italian square, with arcades. The sky is autumnal blue, the shadows are long. In the foreground there is always an array of unaccountable figures and objects, large artichokes, or a girl playing with a hoop, broken classical statuary, and in the background the inevitable train. The general effect is one of enigma. Later, when Guillaume Apollinaire discovered De Chirico, he invented the term *surrealism,* to indicate not irrational, dreamlike fantasy (as the word has come to mean) but realism so charged with a metaphysical awareness of being that it is a revelation.

It is, this vision of De Chirico's, an enigma. That is his own word. It is also Nietzsche's word. The world deprived of illusion and unthinking acceptance is reduced to an enigma, a riddle, a comprehensive reasking of all questions about the nature of reality. De Chirico and his school—Carlo Carrà, Giorgio Morandi, and later by emulation Max Ernst, René Magritte, Otto Dix, Oskar Schlemmer—called themselves *i metafisici.*

Like the English metaphysical poets, they came at a time when science was revising basic tenets. And as for Donne with his maps and com-

passes, the still life of philosophical meditation was a vehicle congenial to them.

De Chirico, in his most characteristic canvases, was fusing still life and landscape. Joyce, at about the same time, was doing the same thing in *Ulysses*. The chapter called the Lestrygonians, in which Bloom has lunch, is a series of symbolic still lifes fitted into a narrative structure that is moreover organized around the idea of architecture (the chapter's "art," as Joyce designated in the schema he made for Linati). Architecture and food come together in various ways. We ornament buildings with garlands of harvest fruit in stone. Joyce's opening words in this chapter, "Pineapple rock, Lemon Platt, Butter Scotch," describe a display of sweets in a shop window, but *pineapple rock* is also a stone pineapple, as on the cornices of neoclassical buildings, a symbol of hospitality.

One way of recognizing verities is to look at them as if you had never seen them before, to make an enigma of the familiar. This "estrangement" of reality, in order to know it at all, was the program of De Chirico's and Joyce's contemporaries Osip Mandelstam and Viktor Shklovski. Mandelstam in his terse novels and tightly wrought poems manipulates the inventory (as of his father's bookshelf, like Joyce cataloging Bloom's books) and the exhaustive list (as of his schoolmates, or the furnishings of an aesthete's rooms) much as De Chirico explores the reality of Turin by dislocating it, arranging it into unfamiliar conjunctions.

Let us look, now, at the fate of a still life in Keats and how its sensual brightness can be reseen in the age of Faraday and Marconi, and then at

a philosophical still life by Shelley, as a first statement of the metaphysical art of De Chirico and all the enigmatic still lifes of our century.

We must approach Keats through Milton:

In *Paradise Regained,* Christ, having fasted in the wilderness for forty days, "hung'ring more to do [his] Father's will" than from "the sting of Famine," dreamed, "as appetite is wont to dream," of Elijah fed by ravens, "Or as a guest with Daniel at his pulse." Waking, he meets Satan in a grove, who invites Him to break his fast, displaying

> In ample space under the broadest shade
> A Table richly spread, in regal mode,
> With dishes pil'd, and meats of noblest sort
> And savour, Beasts of chase, or Fowl of game,
> In pastry built, or from the spit, or boil'd,
> Gris-amber-steam'd; all Fish from Sea or Shore,
> Freshet, or purling Brook, of shell or fin,
> And exquisitest name, for which was drain'd
> Pontus and Lucrine Bay, and Afric Coast.
> Alas how simple, to these Cates compar'd,
> Was that crude Apple that diverted Eve!

Milton's contrast between the cooked and the raw is the tension of his age between archaic Protestant simplicity and Catholic luxury, between farm and castle, chastity and sensuality. The art, however, is baroque, and feeds on both terms of its tense contrast. That fusion of Bible and Greek

myth constitutes the formula for the baroque, exemplified in Bach's masses
(Greek chorus, Roman cadences, arabic musical instruments, Christian
mythos), Racine's *Phèdre* (two myths, rhyming in analogue, one Hebrew,
one Greek, in a provincial dialect of Latin refined to a precision of diction
and elasticity of expression that rivals those of Virgil), and Milton's own
Samson Agonistes (where Jewish folktale and Greek theater are so har-
moniously joined that we feel that the word *renaissance* should never
mean anything other than the cooperation of the Bible with Greek poetry):

> And at a stately side-board by the wine
> That fragrant smell diffus'd, in order stood
> Tall stripling youths rich-clad, of fairer hue
> Than Ganymede or Hylas; distant more
> Under the Trees now tripp'd, now solemn stood
> Nymphs of Diana's train, and Naiades
> With fruits and flowers from Amalthea's horn,
> And Ladies of th' Hesperides, that seem'd
> Fairer than feign'd of old, or fabl'd since
> Of Fairy Damsels met in Forest wide
> By Knights of Logres, or of Lyones,
> Lancelot or Pelleas, or Pellenore;
> And all the while Harmonious Airs were heard
> Of chiming strings, or charming pipes, and winds
> Of gentlest gale Arabian odours fann'd
> From their soft wings, and Flora's earliest smells.

These sixteen lines begin with the odor of wine and end with the fragrance of flowers. With archaic symmetry like that of Mimnermus or the *Iliad*, they resolve into a diptych. Next in toward their center we find Ganymede and Hylas on one side, medieval lovers and knights on the other. Then a symmetry of nymphs and fairy damsels. The median is a blur of northern forests and imaginary islands at the end of the world. The passage also moves from east to west, turning at midpoint eastward again. Such patterns in Milton's still life (analogous to gorgeous Dutch *pronkstillleven* and the richness of Caravaggio and Giorgione) show the allusive versatility of the genre. Local, exact, and palpable, it makes a nest of symbols flown in from elsewhere. It couches time and space in an elegance. Milton's passage will admit of far more extensive unfolding than I have suggested.

I bring it in to help us understand a similar still life in Keats's "The Eve of St. Agnes" for which, along with equally grand descriptions in Spenser, Milton's sensuous rendering serves as the model.

Keats's poem takes its plot from certain old Scottish and English ballads, as does its rude cousin, Scott's "Lochinvar" in *Marmion* (1808). The theme of making off with a bride by a lover unacceptable to her clan runs through Western literature from the *Iliad* forward, with scarcely any epoch in which it has not been popular. Claude Lévi-Strauss's monumental study of the structure of myth—the tetralogy *The Raw and the Cooked, From Honey to Ashes, The Origin of Table Manners,* and *The Naked Man*—keeps returning to the fact of exogamy: taking a wife from another tribe. Intricately bound up with

this theme is the family table, table manners, modes of cooking and eating. It is the general understanding of the primitive mind (which we all have, just below the thin veneer of civilization we have built over it) that one must not marry a wife nearby, such as one's sister or first cousin, as there are no surprises in her for her mother-in-law, no novelty, no frisson of difference. On the other hand, one must not marry a wife with foreign ways and peculiar table manners. One should take a wife from the middle distance. The decisive factor is not, I imagine, the wife's different language or religion, but her table manners and her cooking. In the oldest myths we encounter a world of capricious gods whose energy is spontaneous and unpredictable. Rivers run either way, by whim; the sun and moon wander around the sky. Man is unhappy with the unforeseeable, the unregulated. With heroic efforts he enticed and argued the gods into periodicity, creating day and night, the seasons, a known time for pregnancies, menstrual periods, months, years, and spans of lives. Man's part of the bargain was a cautious and respectful code of behavior, the essence of which is located in table manners, in which Lévi-Strauss sees the source for the dimmest origins of civilization.

If food, its gathering, cooking, and serving, can thus be placed at the nucleus of the family, with all laws and codes of behavior radiating from it, the art of still life takes on another meaning of great brightness.

What is proper to eat, together with the proper way of eating it, is implicit in every still life of food, and it is no longer an accident of vestiges that bread and wine persist in cubist still lifes (to name but one

example of a sacrament surviving the secularization of an art form). The bread and wine were there before they were assigned their sacramental meaning. They were there in the archaic context of a pact with the gods (with gods whose names were forgotten millennia ago) whereby an orderly display and consumption of food was our agreement not to disturb the stars in their courses.

Porphyro, the lover in Keats's poem "The Eve of St. Agnes," makes his way to Madeline's bedroom, and before waking and making off with her, builds a still life by her bed. It is not for them to eat (it would wreck the tone of the poem if they did); it is pure symbol, like the song he sings to waken her. Here is the still life:

> And still she slept an azure-lidded sleep,
> In blanched linen, smooth, and lavender'd,
> While he from forth the closet brought a heap
> Of candied apple, quince, and plum, and gourd;
> With jellies soother than the creamy curd,
> And lucent syrops, tinct with cinnamon;
> Manna and dates, in argosy transferr'd
> From Fez; and spiced dainties, every one,
> From silken Samarcand to cedar'd Lebanon.
>
> These delicacies he heap'd with glowing hand
> On golden dishes and in baskets bright
> Of wreathed silver: sumptuous they stand

In the retired quiet of the night,
Filling the chilly room with perfume light.

A happy, Joycean tangle of etymologies makes serendipitous puns, so that the formulaic apple and pear lead the inventory of Keats's still life. Quince is in Greek poetry (Ibycus, for example) a Cydonian apple, and botanically it is a Cydonian pear *(Pyrus cydonia)*. Cydonia is in Crete, or as the Elizabethans (Chapman, for example) called it, Candy, so that "Candied apple, quince" reads "apple and pear from Crete, where Cydonia is, the sacred precinct of Aphrodite." Porphyro (purple) is an apple color, and a madeline is a kind of pear. Apple toppled us from grace; pear, symbol of incarnation, saved us. Madeline is the name of a woman redeemed by Christ, therefore the type of all who are saved. Apple and pear together are a symbol of all things that belong together by natural affinity.

And when the skeptical student in the back of the room asks if Keats knew this, and intended it, we must say no, but that language knew it for him, and carried the meaning as genes pass on information from organism to organism. Keats knew herbals, as a poet and pharmacist; he knew Milton, Spenser, and the Bible. He used words as an artist uses colors, with harmony taking precedence over local accuracy.

Plum and gourd, jellies, lucent syrops, tinct with cinnamon (notice the three pharmaceutical terms), manna and dates, spiced dainties: the rest of the still life is a medieval dream of trade routes from the East. "The Eve of St. Agnes" is a poem in which a webwork of symbols and

allusions keeps making figures in the carpet. Lévi-Strauss's culinary chord of honey and ashes appears in it alongside images of narcosis, of sexual delights inextricably interwoven with those of delicious food.

In 1902, Rudyard Kipling published a story called "Wireless." In it a young pharmacist with a girlfriend named Fanny go for a walk on a bitter cold evening to the Church of St. Agnes. The first clue we have of what Kipling is up to comes on the fifth page: "In the Italian warehouse next door [to the pharmacy] some gay-feathered birds and game, hung upon hooks, sagged to the wind across the left edge of the window-frame."

"'They ought to take these poultry in—all knocked about like that,' said Mr. Shaynor. 'Doesn't it make you feel fair perishing? See that old hare! The wind's nearly blowing the fur off him.'" This is Kipling making a modern British equivalent of:

> St. Agnes' Eve—Ah, bitter chill it was!
> The owl, for all his feathers, was a-cold;
> The hare limp'd trembling through the frozen grass,
> And silent was the flock in woolly fold.

Keats then describes a monk telling his rosary with icy fingers; next in Kipling is a man coming in from the cold rubbing his hands together. But Kipling's story is ostensibly about the pharmacist's nephew, who has constructed a Marconi receiver to pick up the wireless telegraphy from Poole. In 1902 Marconi had just achieved his earliest successes. Ships at sea (as in Kipling's story) were able to communicate with shore

stations, and with each other, for up to several miles. (From Clerk Maxwell's theory of magnetic fields that led to the first description of light, which changed painting from the early nineteenth century onward—the single-source raking slants of light in Peto and Harnett are Maxwellian, streaming onto and around objects, as light in Caravaggio is da Vincian, omnidirectional, suffused in a glow, and as if arising from the objects themselves—from Clerk Maxwell's theory to Kipling's story a vision of particles in waves has gone from visible light blessing all that it touches to invisible, shorter, Herzian waves of such subtlety and demonic powers of leaping that they will in a matter of a few years carry not only dots and dashes but the human voice itself right around the globe.) Trust Kipling to have seen in wireless telegraphy the art of Keats. His story reads two ways at once. His tubercular pharmacist in an English town, who will not live to marry his girlfriend Fanny, is in some sense another Keats, and Kipling fills the story with double meanings that suggest "The Eve of St. Agnes" and the nightingale ode. But what Kipling is doing is writing an analytical essay in which genius is equated with wireless telegraphy.

Culture is like a magnetic field, a patterned energy shaping history. It is invisible, even unsuspected, until a receiver sensitive enough to pick up its messages can give it a voice. When Ezra Pound said that poets are the antennae of the race, he meant radio antennae, not insects' only. Keats's tiger moth, then, may be the key symbol to his poem: the creature that can call to its mate over a distance greater than any other in courtship, with the possible exception of the whale.

The enigmatic melancholy that Nietzsche felt in autumn light in Turin was the death of Keats's world. Kipling felt the same passing of a coherent order, and like De Chirico and Joyce saw a new world born in the dynamo and the internal combustion engine, but did not know what kind of soul would inhabit them. The only automobile in Joyce moves, like the trams of Dublin, in circles.

Shelley, in his verse letter to Maria Gisborne of 1820, describes a still life that, for detail and tone, is worthy of Holbein. We can probably trace his inspiration to Keats's similar verse letter to Charles Cowden Clarke (1817), as well as to Keats's description of Leigh Hunt's study in "Sleep and Poetry," which Shelley indeed mentions in the course of this poem. Shelley's 322 lines to the Gisbornes in London—Maria James Revely Gisborne, her husband John, and her son by a previous marriage, the engineer Henry Revely—were written from Henry's workroom in their house in Leghorn. They were engaging people of whom the Shelleys were fond. Of Henry Revely we know that he once saved Shelley's life when he had fallen into a canal, and that he and Shelley were planning to found a steamship company plying between Marseille and Genoa (the first ocean-going steamship, the *Savannah*, had crossed the Atlantic two years before, in 1818, and the first iron steamship had just been built, and we are only seventeen years beyond the August day when Robert Fulton chugged along the Seine through Paris on his "water chariot moved by fire," as the memorial inscription says, with Citizens Bossut, Carnot, Prony, and Volney on board—Volney who had inspired "Queen Mab" and "Ozymandias"). Revely later emigrated to Australia and is lost sight

of to literary history. The verse letter is prophetically full of images of shipwreck.

The still life in this poem comes after a whimsical prologue and before a charming list of all the people the Gisbornes might visit in London: Leigh Hunt, Thomas Love Peacock, Samuel Taylor Coleridge, Thomas Jefferson Hogg, William Godwin.

After a description of Henry Revely's workshop, plans of steamships, pieces of machinery, "Great screws, and cones, and wheels, and grooved blocks," Shelley turns to the worktable:

> Upon the table
> More knacks and quips there be than I am able
> To catalogize in this verse of mine:—
> A pretty bowl of wood—not full of wine,
> But quicksilver; that dew which the gnomes drink
> When at their subterranean toil they swink,
> Pledging the demons of the earthquake, who
> Reply to them in lava—cry halloo!
> And call out to the cities o'er their head,—
> Roofs, towers, and shrines, the dying and the dead,
> Crash through the chinks of earth—and then all quaff
> Another rouse, and hold their sides and laugh.
> This quicksilver no gnome has drunk—within
> The walnut bowl it lies, veined and thin,
> In colour like the wake of light that stains

The Tuscan deep, when from the moist moon rains
The inmost shower of its white fire—the breeze
Is still—blue Heaven smiles over the pale seas.
And in this bowl of quicksilver—for I
Yield to the impulse of an infancy
Outlasting manhood—I have made to float
A rude idealism of a paper boat—

(Shelley in bedroom slippers, this spontaneous verse, and it is a privilege to see the author of "Prometheus Unbound" sailing a paper boat on a bowl of mercury, but we should also notice in his playful, lava-swilling gnomes that he is showing off his new knowledge of the relationship between earthquakes and volcanoes, just then being suspected.) He continues:

A hollow screw with cogs—Henry will know
The thing I mean and laugh at me,—if so,
He fears not I should do more mischief.—Next
Lie bills and calculations much perplext,
With steam-boats, frigates and machinery quaint
Traced over them in blue and yellow paint.
Then comes a range of mathematical
Instruments, for plans nautical and statical;
A heap of rosin, a queer broken glass

With ink in it;—a china cup that was
What it will never be again, I think,
A thing from which sweet lips were wont to drink
The liquor doctors rail at—and which I
Will quaff in spite of them—and when we die
We'll toss up who died first of drinking tea,
And cry out, heads or tails? where'er we be.

(Notice that drink, first quicksilver and now tea, has got into this scientific still life for a second time, objects native to a genre having their way.)

Near that a dusty paint box, some odd hooks,
A half-burnt match, an ivory block, three books,
Where conic sections, spherics, logarithms,
To great Laplace, from Saunderson and Sims,
Lie heaped in their harmonious disarray
Of figures,—disentangle them who may.

(Is there a better expression for the kind of still life Shelley is describing than "harmonius disarray"? The "Saunderson" is Nicholas Saunderson [1682–1739], blinded by smallpox as an infant, who lectured on Newton at Cambridge, and was Professor of Mathematics from 1711, and a fellow of the Royal Society. Sims I have not identified.)

Baron de Tott's Memoirs beside them lie,
And some odd volumes of old chemistry.

(Baron François de Tott [1733–1793] was a French sol-
dier of Hungarian extraction, whose *Memoires sur les
Turcs et les Tartars* was published in 1784.)

Near those a most inexplicable thing,
With lead in the middle—I'm conjecturing
How to make Henry understand; but no—
I'll leave, as Spenser says, with many mo,
This secret in the pregnant womb of time,
Too vast a matter for so weak a rhyme.

(The unnamed object is a theodolite, and Spenser's words
are Shakespeare's [*Richard II*, II.1.239].)

Whoever should behold me now, I wist,

(writes a poet of renewals, rebellions of the spirit, of
shamanistic calling up of winds and the skylark, medi-
ator between the daimons of the air and humankind)

Would think I were a mighty mechanist,
Bent with sublime Archimedean art

To breathe a soul into the iron heart
Of some machine portentous, or strange gin,
Which by the force of figured spells might win
Its way over the sea . . .

Shelley's still life of Henry Revely's tabletop is a permutation of the poem's philosophical concerns. In the engineer Shelley sees a new kind of creating spirit. If the poet's calling is to "rouse with the spirit's blast / Out of the forest of the pastless past," "The purposes and thoughts of men whose eyes / Were closed in distant years—or widely guess / The issue of the earth's great business," the man of science inherits the heroism of Prometheus. Shelley wrote this poem, as he keeps us aware, near wheat fields, vineyards, and a silkworm industry. The third and fourth lines of the poem are: "The silkworm in the dark-green mulberry leaves / His winding-sheet and cradle ever weaves."

Composite births and deaths had been happening for the last forty years, of republics and constitutional monarchies arising out of the deaths of tyrannies; an impending scientific revolution was bringing steam power and electricity into the world, and the sense was that these harnessed energies would belong not to the king and church but to the people. In Revely's tabletop Shelley sees a new wave of the Renaissance, one in which knowledge discontinued in the pre-Socratics or lost in indifference or lack of vision after Lucretius is about to be reborn. That broken teacup in service as an inkpot, that walnut bowl now containing quicksilver, rhyme with the volume of Laplace: new learning is taking over. That paper boat

is a toy symbolizing Shelley's magic boats and chariots, conveyors of liberating spirits, as in "The Witch of Atlas" and "Prometheus Unbound" It is the genius of the creative spirit buoyant upon a liquid metal named for the god who gave us the alphabet, a metal that is alive—*quick*, that is *living*, silver.

Shelley is not the only poet to object to the idea of death in the phrase *nature morte*. The words *still* and *quick* descend to us from the ancient understanding that stone in the quarry is alive, but once parted from the earth it is dead, as in the word *mortar* for crushed rock. And the phrase "the living stone." Matter, we have learned from Rutherford and Einstein, is wildly alive; that is, we have returned to matter in its archaic state: it has a fiery, electrical, dancing aliveness—a scientific truth adumbrated throughout Shelley's thought.

Charles Olson, in a poem called "The Morning News," has these lines:

> Natura NON morte:
> it was a bowl of fruit
>
> . . .
>
> a bowl, a golden bowl, in any day
> put out there, on the table, as jewels
> were worn, in fact, as the fine birds
> were wrought, the pair of peacocks' heads,
> say, set with the Syrian garnets
> Neither to be eaten nor
> to be made pretty of.

Olson is feeling in these lines the metaphysical condition of art: it is artificial, inorganic, made of stone, paint, the scrawl of ink or graphite along paper, metal keys of the typewriter stamping damp carbon onto blanched wood pulp, while being alive with meaning. This paradox threads through myth: golden apples, silver apples. In our time those fusions of the dead and the living (the realms of Hades and Demeter, so the Greeks understood) have claimed Shelleyan (and Ovidian) attentions in such diverse artists as William Morris, William Butler Yeats, Eudora Welty, and Ray Bradbury, all of whom have evoked the golden apples of the sun and the silver apples of the moon (images encoding the kinship of apple and pear, the complementarity of male and female, of Heraclitean opposites requiring each other to exist at all).

In still life, down through history, we find an ongoing meditation on where matter ends and spirit begins, and on the nature of their interdependence.

Joyce, who left no genre and no art untouched or unchallenged, deployed still lifes throughout his work. The first sentence of *Ulysses* is one: "Stately, plump Buck Mulligan came from the stairhead, bearing a bowl of lather on which a mirror and a razor lay crossed."

William Harnett or John Peto, painters of bachelors' parlor tables and dresser tops, might have painted the subject. In classical times Scipio Africanus had made the shaven face fashionable: in 1904 the Victorian beard was being routed by soap, stainless steel, the celluloid collar, and the dandy. Among the multiple symbols of Mulligan's shaving bowl we can locate Homer's invocation to the Muse to hold up the mirror of art

to a tale of sharp-edged weapons. The mirror is Stephen's symbol, the razor Mulligan's lancet (he is a medical student). Mulligan, playing priest to shock Stephen, makes his shaving bowl a parody monstrance, but he is also playing priest on other levels. His yellow gown, the mirror and razor, indicate that he is a Mithraic hierophant who has just sacrificed a bull and is flashing sunlight with a mirror to the four cardinal points.

Joyce is always going to see the mass in every still life, for the chief business of his art in *Ulysses* is to transubstantiate matter into spirit.

For three centuries still life secularized from religious painting, and we could note that the sacred stubbornly kept its iconographic integrity, so that Picasso's constant theme of bread, wine, and book illustrates a persistence of myth. With Joyce the process reversed, and the sacred was returned to the secular. Bloom, too, is introduced to us with a still life of Hebraic burnt offerings. Joyce delights in wrapping his rhythmic symbols in involucra appropriate to the styles of each chapter of *Ulysses*.

As Stephen enters in the Circe chapter, he is drunkenly trying to mime the verse of the *Rubaiyat of Omar Khayyám* in which a jug of wine, a loaf of bread, and thou beneath a palm tree were paradise enow, but we can easily see that it is the Eucharist right on.

In chapter 17 of *Ulysses* (Ithaca, Bloom at home preparing to go to bed), we have this mantelpiece still life in the bedroom:

> A timepiece of striated Connemara marble, stopped at the hour of 4.46 a.m. on the 21 March 1896, matrimonial gift of Matthew Dillon: a dwarf tree of glacial arborescence under a

transparent bellshade, matrimonial gift of Luke and Caroline
Doyle: an embalmed owl, matrimonial gift of Alderman John
Hooper.

Matthew, Mark, Luke, and John, together with Christ ("Doyle"), fig-
ure in the pattern, as does a symbolism of stopped processes (marble,
clock, dwarf tree made of glass, an embalmed owl) that depict Bloom's
frozen marriage, and some of the reasons for it. The owl can be located
elsewhere, notably in all the first sentences of each of *Ulysses'* three divi-
sions. It is concealed in the word *bowl* (on which the razor and mirror
lay crossed), in the word *fowl* ("inner organs of beasts and fowls"), and
at a deeper level in the opening sentence of the third section, where
phrases from the first sentence appear tangled in the texture ("bucked
him up," "brushed off the greater bulk of the shavings"), and to find the
owl we must hear—anticipating the method of *Finnegans Wake*—the
Gaelic for owl, *ullchabhant* (ull'shawv'n), in the phrase "bulk of shav-
ings."

More clearly, the owl pays homage to Felicité's parrot in *Un coeur
simple* of Flaubert. That story, indeed, showed Joyce how still life can
be a pattern of symbolic meaning. *Un coeur simple* begins with a
description of Madame Aubain's sitting room, the furnishing of which
gives us her character and place in French society before she herself
comes onstage; and the ending of the story is a still life of great radi-
ance. Felicité, we remember, is a servant of stoic character, who out-
lives the family with whom she has spent all her life and whose life

was hers. At the last her only source of affection, the only thing she has left to love with her saintlike solicitude, is her parrot Lulu, dead and stuffed. It was still the custom to display one's finest household furnishings in the street on Corpus Christi day—so many still lifes along a street, to be blessed by the passing Host. Felicité has only her parrot Lulu to display, and dies with his image in her imagination, an image that focuses all her love: for her nephew, for God (the colors of its feathers remind her of the church's stained glass windows, as of the map of the new world where her nephew went as a sailor).

All but two of the fifteen stories in *Dubliners* contain a clearly described still life that functions as a bit of genetic code in which we can descry an emblematic miniaturization of the plot.

Characteristically, these still lifes develop from a simple one of sherry and cream crackers (wine and bread) in the first story, "The Sisters," to an elaborate Dutch *pronkstillleven* in the last, "The Dead":

> A fat brown goose lay at one end of the table and at the other end, on a bed of creased paper strewn with sprigs of parsley, lay a great ham, stripped of its outer skin and peppered over with crust crumbs, a neat paper frill round its shin and beside this was a round of spiced beef.

> (So far, we can see three kinds of Irish: emigrants and exiles in the goose, peasants in the pig, the Anglo-Irish

in the beef. And the goose translates into barnacle, into Nora Barnacle, Joyce's wife, who posed for Gretta.)

Between these rival ends ran parallel lines of side-dishes: two little ministers of jelly, red and yellow; a shallow dish full of blocks of blancmange and red jam, a large green leaf-shaped dish with a stalk-shaped handle, on which lay bunches of purple raisins and peeled almonds, a companion dish on which lay a solid rectangle of Smyrna figs, a dish of custard topped with grated nutmeg, a small bowl full of chocolates and sweets wrapped in gold and silver papers and a glass vase in which stood some tall celery stalks. In the centre of the table there stood, as sentries to a fruit-stand which up-held a pyramid of oranges and American apples, two squat old-fashioned decanters of cut glass, one containing port and the other dark sherry. On the closed square piano a pudding in a huge yellow dish lay in waiting and behind it were three squads of bottles of stout and ale and minerals, drawn up according to the colours of their uniforms, the first two black, with brown and red labels, the third and smallest squad white, with transverse green sashes.

The coloring is by the Manet of *A Bar at the Folies-Bergère*, and before our eyes, bottles turn into armies in parade dress. Symbolically, these are the suitors preparing to defend themselves against Odysseus.

In the story "Clay," which sustains a grotesque allusion to Nausicaa's encounter with Odysseus (the princess washing her wedding clothes in a creek becomes a Dublin spinster who works in a laundry), we have an arrangement of seven still lifes, from the Chardin-like interior of the tea pantry at the laundry to a game at a Halloween party of fortune-telling objects on a table, to be touched blindfolded (prayer book, ring, water, clay).

The art of our century is that of collage, involving quotation, parody, cultural inventory. Collage is by genre and by strategy the art of still life, which begins as a duplication of reality in an image, grows into an enduring depiction of symbolically interacting objects in the service of one sentiment or another, and in our time takes on a new significance as a way of deploying dramatic information (as in the hundreds of still lifes in *Ulysses*), or as the only way of stating the new enigma of reality that came in with the century.

Collage became the mode of many still-life painters: Kurt Schwitters, who pasted debris from the street (streetcar tickets, advertisements, soiled paper) to make what he called *Merzbilder*: the allusion is *Kommerz*. Joyce had already seen that there is an urban poetry in newspapers, posters, old photographs. Max Ernst, Picasso, Braque. We can see this spirit of recycling forms and subjects in literature's propensity to follow Nietzsche in his saying that, human nature being unchanging, the same things must happen over and over again.

Shelley's verse letter to Maria Gisborne is the re-use of an ancient literary device, the speculative letter to a friend, meant for all the world to

read, but already it begins the new cycle of literature in which all forms dissolve into a parody of form rather than form itself. Piet Mondrian's naked lines and spare areas of primary colors began as still lifes. Proust, in one of his most triumphant moments, has us read not the page before us but certain imaginary pages of the Goncourt journals displacing his page. This is Joyce's ruling stylistic strategy. Pound's *Cantos* are a mural-sized collage in the manner of a Vorticist design by Wyndham Lewis.

Age after age, still life has run its course from innovation to triteness, dissipating itself in familiarity. Inevitably, it has regenerated itself, usually as the stylistic forerunner of a new direction in the arts, or as the epitome of a style.

When Chardin in the middle of the eighteenth century remade French still life as an art of incomparable richness—a richness that would feed French painting through realism in the nineteenth century on out to the still lifes of Georges Braque—he was working within the intellectual and spiritual harmony of Haydn's string quartets and the prose of Samuel Johnson's *Life of Boerhaave,* all of which share a warmth, a decisive clarity.

To move from the harmonies of Chardin to Cézanne, and from Cézanne to Braque and Picasso, and from them to the geometric enigmas of De Chirico, is to move from Amos's vision of a basket of summer fruit to his vision of God making a wall with a plumb line. Still life would seem to be a symbol of one or the other of these visions: to picture the harvest and to be mindful of our stewardship of it, and of our

contract with nature; or to state the architecture of nature's foundations, about which our understanding changes age after age. Joyce, in making so much of Bloom's room and board, his food and the shelters of his city, placed still life in its soundest tradition, at the still center of civilization. This interrelation of architecture and still life has yet to be explored. In Poe there is no food on a table, only books and musical instruments, and the House of Usher splits and falls into the abyss. Picasso's images group themselves at the poles of violence and domestic tranquillity. Eliot, in "Burnt Norton," having evoked a bowl of rose leaves on a table (Keats gazing at a Greek vase, William Carlos Williams at cool plums in a refrigerator, Cézanne at apples and pears in a country kitchen), meditates that

> Only by the form, the pattern,
> Can words or music reach
> The stillness, as a Chinese jar still
> Moves perpetually in its stillness.

NOTES

A BASKET OF SUMMER FRUIT

Kafka's parable of the leopards is in his *Parables and Paradoxes* (New York: Schocken Books, 1958).

The translations from the *Anthology* and Herondas are mine.

The passage I examine in Hugh Miller's *The Cruise of the Betsey* is on page 26 of the first American edition (1858), published the year after his death.

112 • NOTES

THE HEAD AS FATE

The phrase *der Kopf als Schicksal* is used by Leo Frobenius in his *Erlebte Erdteile* of Benin portrait bronzes, masks, and the classical bust.

The translation of Rilke's "Archaic Torso of Apollo" is that of J. B. Leishman in *Requiem and Other Poems* (London: The Hogarth Press, 1949).

APPLE AND PEAR

Meyer Schapiro's essay "The Apples of Cézanne: An Essay on the Meaning of Still Life" is in his *Modern Art in the Nineteenth and Twentieth Centuries: Selected Papers* (New York: George Braziller, 1978).

METAPHYSICAL LIGHT IN TURIN

The translation of Nietzsche's letter is by Christopher Middleton in his edition and translation of Nietzsche's letters.

Paul Deussen's description of Nietzsche's room at Sils-Maria is from Ivo Frenzel, *Friedrich Nietzsche: An Illustrated Biography* (New York: Pegasus, 1967.)

BIBLIOGRAPHY
of works consulted or alluded to

Bergström, Ingvar. *Dutch Still-Life Painting in the Seventeenth Century*. Translated by Christina Hedstrom. New York: Hacker Art Books, 1983.

Bohrod, Aaron. *A Decade of Still Life*. Madison: University of Wisconsin Press, 1966.

Bryson, Norman. *Looking at the Overlooked: Four Essays on Still Life Painting*. Cambridge: Harvard University Press, 1990.

Cikovsky, Nicolai Jr., Linda Bantel, and John Wilmerding. *Raphaelle Peale Still Lifes*. New York: Harry N. Abrams, National Gallery of Art, and the Pennsylvania Academy of the Fine Arts, 1988.

Dars, Célestine. *Images of Deception: The Art of Trompe-L'œil*. Oxford: Phaidon, 1979.

De Chirico, Giorgio. *Memoirs*. Translated by Margaret Grosland. Coral Gables: University of Miami Press, 1971.

Ember, Ildikó. *Delights for the Senses: Dutch and Flemish Still-Life Paintings from Budapest*. Wausau, Wis.: Yawkey Woodson Art Museum and the Museum of Fine Arts, Budapest, 1989.

Foster, Richard, and Pamela Tudor-Craig. *The Secret Life of Paintings*. New York: St. Martin's Press, 1986.

Frenzel, Ivo. *Friedrich Nietzsche: An Illustrated Biography*. Translated by Joachim Neugroschel. New York: Pegasus, 1967.

Gerdts, William H. *Painters of the Humble Truth: Masterpieces of American Still Life 1801–1939*. Columbia, Mo., and London: University of Missouri Press and the Philbrook Art Center, 1981.

Gombrich, E. H. *Meditations on a Hobby Horse*. London: Phaidon, 1963.

Jordan, William B. *Spanish Still Life in the Golden Age 1600–1650*. Fort Worth: Kimball Art Museum, 1985.

Miller, Hugh. *The Cruise of the Betsey, or A Summer Ramble among the Fossiliferous Deposits of the Hebrides*. Boston: Gould and Lincoln, 1858.

Nietzsche, Friedrich. *Selected Letters of Friedrich Nietzsche*. Edited and translated by Christopher Middleton. Chicago: University of Chicago Press, 1969.

Nordenfalk, Carl. "Van Gogh and Literature," *Journal of the Warburg and Courtauld Institutes* 10. The Warburg Institute, University of London, 1947.

Poe, Edgar Allan. *Collected Works*. Edited by Thomas Ollive Mabbott. Cambridge, England: The Belknap Press, 1969–1978.

Praz, Mario. *An Illustrated History of Furnishing from the Renaissance to the Twentieth Century*. Translated by William Weaver. New York: George Braziller, 1964.

Schapiro, Meyer. *Modern Art in the Nineteenth and Twentieth Centuries: Selected Papers.* New York: George Braziller, 1978.

Schneider, Norbert. *The Art of Still Life: Still Life Painting in the Early Modern Period.* Cologne: Benedikt Taschen, 1990.

Spike, John T. *Italian Still-Life Painting from Three Centuries.* Florence: Centro Di, 1983.

Sterling, Charles. *Still-Life Painting from Antiquity to the Twentieth Century.* New York: Harper and Row, 1981.

van Gogh, Vincent Willem. *The Complete Letters of Vincent van Gogh.* Greenwich, Conn.: New York Graphic Society, 1958.

Wilmerding, John. *Important Information Inside: The Art of John F. Peto and the Idea of Still-Life Painting in Nineteenth-Century America.* Washington, D.C.: National Gallery of Art, 1983.

Printed in the United States
By Bookmasters